# Painting Still Life in Watercolour

*Lesley E Hollands*

THE CROWOOD PRESS

First published in 2009 by
The Crowood Press Ltd
Ramsbury, Marlborough
Wiltshire SN8 2HR

**www.crowood.com**

**British Library Cataloguing-in-Publication Data**
A catalogue record for this book is available from the British Library.

ISBN 978 1 84797 121 0

Frontispiece: *The Artist's Studio*

Typeset by Servis Filmsetting Ltd, Stockport, Cheshire
Printed and bound in Singapore by Craft Print International

# CONTENTS

Introduction 7

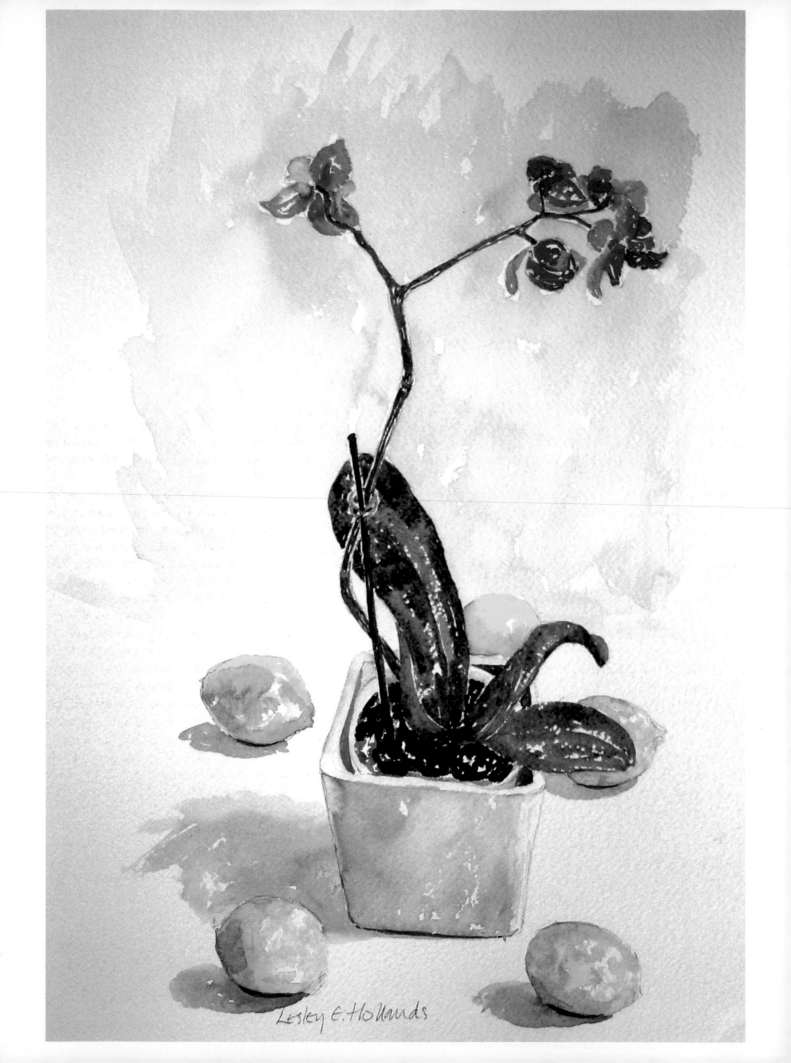

Lesley E. Hollands

# INTRODUCTION

Watercolour has been a medium much enjoyed by both amateurs and professionals for many, many years. In the eighteenth century J.M.W. Turner created the most innovative and imaginative paintings using watercolour. Thomas Girtin and John Sell Cotman were also masters of the medium. In America, slightly later, Winslow Homer produced some magnificent watercolour paintings. In the nineteenth century watercolour was very popular with Victorian ladies and was often the chosen medium when travelling, as its fast, fresh approach was ideal for recording passing scenes.

More recently watercolour has become increasingly popular, with exhibitions, competitions and galleries being devoted exclusively to the medium. The Royal Watercolour Society is housed at the Bankside Gallery in London and has regular shows of members' work as well as open exhibitions. Living painters who use watercolour include David Hockney RA, who works in America and England using a wide range of media including watercolour and has his own website where you can see his work. Pamela Kay ARCA, RWS, RBA, NEAC, is an English painter who works in water-based media and oil and is renowned for her beautiful, tranquil but strong still-life paintings. In addition there is Elizabeth Blackadder RA, a Scottish Artist; Paul Riley and Mike Bernard also work in watercolour using very different styles. Edward Burra (1905–1976) is also a very interesting painter in quite a different style. Mary Feddon RA is another innovative painter who works mainly on still life but in a very individual way. She paints mostly in oils but a lot can be learnt from looking at the way she puts things together.

It is well worth looking at some or all of these painters, and of course there are many more who have not been mentioned here. They can give you an insight into the wide range of methods and approaches being used.

For a while now there seems to have been an ever-increasing number of rules applied to watercolour painting, such as 'you must not use opaque paint as you lose the transparency of colour' (opaque paint was known as 'body colour' in the time of Turner and Cotman); or 'you must not use masking fluid because this gives too mechanical an effect'; or 'you must not use more than three colours as this is over-indulgent and lazy'.

When you look at how watercolour has been used in the past, and is being used now, you realize what nonsense all this is. Turner used any method that suited him to get the effects that he wanted to achieve. He would move the paint with his fingers; scratch it out; over paint; use gouache; whatever was necessary. Today Elizabeth Blackadder's beautiful, powerful yet almost ethereal work includes, amongst other things, splashes and drips of colour, revealing her cats asleep among the still life and bits of gold leaf. At times, Edward Burra worked in a very stylized way on some of his paintings, drawing out the whole composition in detail and then filling in the lines working from top to bottom and left to right.

Another myth is that watercolour is a particularly difficult medium. True, it can be difficult to put mistakes right once you have made them, but the more painting you do, the fewer mistakes you are likely to make and the more confident you become in dealing with them. Many 'accidents' if looked at in the right way can become happy variations on what was first intended. Watercolour can be washed out, unless it is a staining colour, scrubbed off or repainted with a more opaque pigment. If you have a heavy enough paper you can even remove paint

OPPOSITE PAGE:
**Orchids and lemons.**

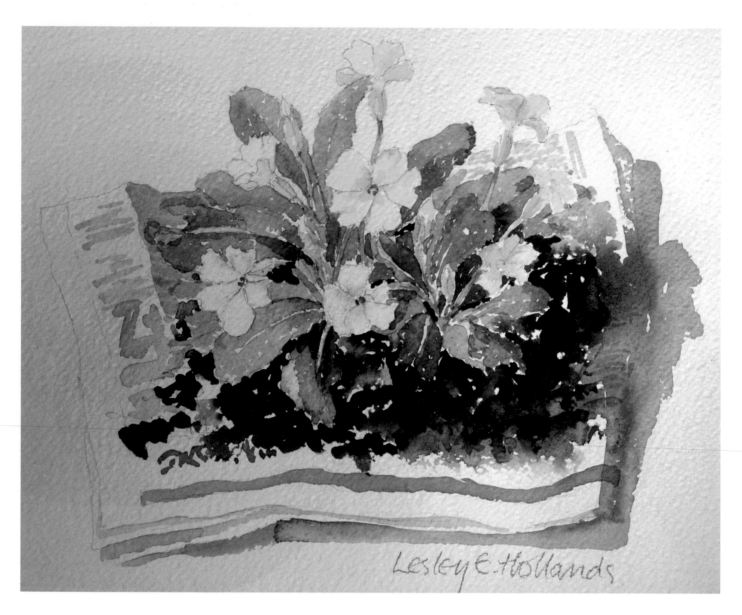

**Primroses dug from the garden.**

with sandpaper or a craft knife, although this is something of a last resort unless you are looking for a particularly textured area as part of your composition.

The main reason for saying all this is to help to free you up and allow you to find your own style and approach; to make your own rules and break them if necessary. Let your enjoyment shine through in whatever you do. Most importantly, do not give up and remember the famous saying attributed to Rodin amongst others: 'Art does not reproduce the visible; rather it makes visible.'

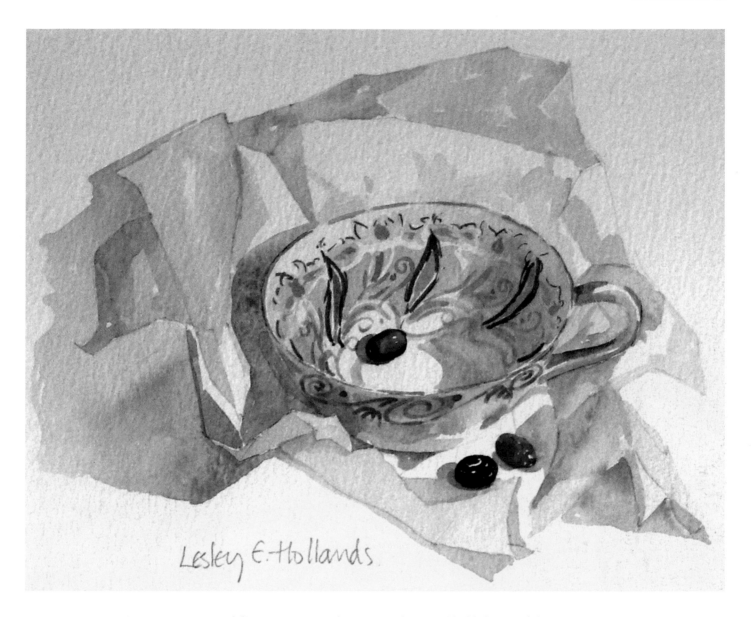

Lesley E. Hollands

**Tissue paper gives a delicate contrast to the strong colours and bold shapes of the cup and beads.**

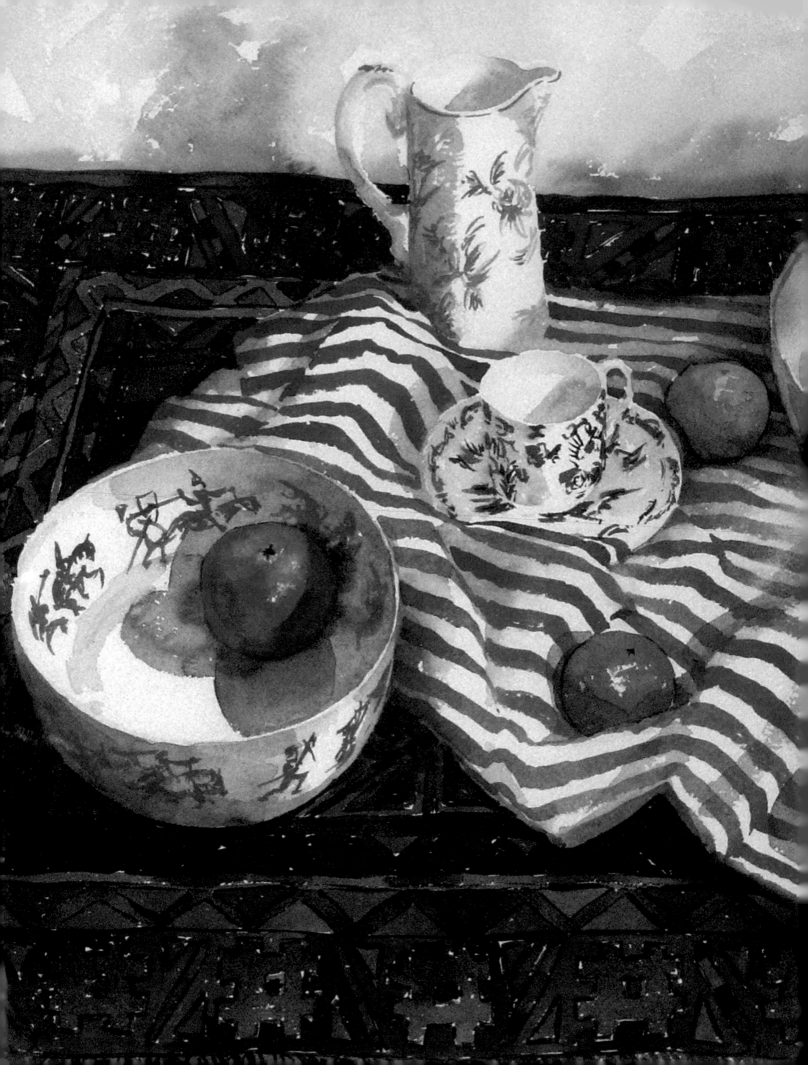

# MATERIALS AND EQUIPMENT

## EQUIPMENT

One of the many joys of watercolour is that you do not need a huge quantity of equipment to get started. Of course you can spend a great deal and starting with watercolour is the ideal gift solution for all your family and friends. The basic equipment that you will need is a small range of watercolours, two brushes, a mixing pallet, a water pot and some kitchen towel.

## Paints

There are three ways in which watercolours are available to buy: pans, half pans and tubes. Which you choose is a matter for personal choice but here are a few things you might like to think about before making a decision.

Tubes are ideal if you are working on a large scale as they allow you to put out a generous quantity of paint with ease. However, if you do not use what you put out, the paints dry very hard and are difficult to reuse so could be wasteful.

Pans allow you to access the full range of your colours with ease, but if working on a large scale it can be difficult to get enough pigment to give you a good strong colour where you need it. Tubes can be kept in any sort of box that is convenient to you but pans do need a purpose-made box to hold them in place. You can buy boxes of pans but they do not always contain the most useful colours and you can also buy empty tins that allow you put in your own selection. Whichever type you decide to go for, buy the best you can afford. Most manufacturers

OPPOSITE PAGE:
**Stripes and china.**

make an Artist and a Student range. The Student ranges have been much improved in recent years but they do not match the brilliance and intensity of colour that you can achieve with the Artist colours. Student colours have less pigment in them and more filler and tend to be harder so need more scrubbing with the brush to release the colour. Artist paints are more expensive initially, but you need less of them to get a good colour so you could think of them as being cheaper in the long run. You may also be more satisfied with the results from the better quality paints and waste less paper along the way.

Watercolour paints have four particular characteristics that are worth knowing about. Some are transparent, some are opaque, some will granulate and some will stain:

- **Opaque colours** include: Cadmium Red, Yellow and Orange, Naples Yellow, Venetian Red, Indian Red, Blue Black and Titanium White.

- **Transparent colours** include: Indian Yellow, Quinacridone Red, Permanent Alizarin Crimson, Permanent Carmine, Rose Madder Genuine, Permanent Magenta, Winsor Violet, Hooker's Green, Permanent Sap Green and Raw Sienna.

- **Granulating colours** include: Rose Madder Genuine, Permanent Mauve, French Ultramarine, Raw Sienna and Raw Umber.

- **Staining colours** include: Cadmium Yellow, Transparent Yellow, Scarlet Lake, Winsor Red, Rose Dore, Permanent Alizarin Crimson, Permanent Rose, Permanent Carmine, Winsor Violet, Permanent Sap Green, Hooker's Green, Venetian Red, Payne's Grey and Indigo.

Student pans.

Artists' watercolour tubes and pans.

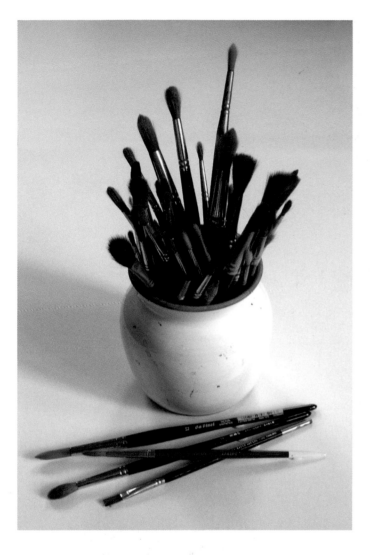

**A collection of brushes.**

just starting out. If you find that you really enjoy watercolour painting and are doing a lot of it then it is probably worth investing in one or two. There are a number of sites on the internet where you can buy them for a better price than your local art shop can possibly offer. There are some excellent synthetic and synthetic/sable mix brushes on the market at very reasonable prices. Choose two as a minimum, a Number 6 and a Number 8 or 10. Select brushes that come to a clean point when wet and avoid those that stay splayed out as these are only useful for washes and broad areas. A large brush with a good point can give you a fine line that opens out into a broad mark and back again all in one stroke, whereas a small brush can only give you a small mark. A large brush also holds more paint, which allows you to be freer and more fluid with your painting. Another type of brush is a rigger, called this because they were used for painting the rigging on pictures of ships. This brush gives a very long, narrow, even-width stroke, which is not particularly useful when painting still life.

Look after your brushes and they will last you a long time – the most common damage to a brush is bending the hairs. This can happen if you leave brushes standing in water or you do not pack them properly when transporting them. To prevent damage in transit either roll them in a cloth, put them in a purpose-made storage tube or, simplest and cheapest, cut a piece of stiff card longer than your longest brush, make a notch in each side top and bottom and hold your brushes on this with a couple of elastic bands.

## Paper

There is an enormous range of papers available for the watercolour painter. Whatever you choose to use it must be one that has been made for painting, not just drawing. A drawing paper, such as cartridge, which has not been sized, will not allow you to move and manipulate the paint as a purpose-made watercolour paper does. Sizing is the reduction of absorbency in the sheet and without it the paint sinks into the surface immediately, which makes moving the paint pretty well impossible. Most watercolour papers are sized internally so that the size has bonded with the fibres; this allows you to scrub out paint and generally be fairly rough with it without losing the surface texture.

Paper comes in a variety of surfaces and weights. The heavier the weight, the thicker the paper and the less likely it is to buckle and distort when you use it. If you choose a lighter-weight paper you will have to stretch it, a process that will be explained later in this chapter. To avoid having to stretch the paper chose a weight of 140lb/300gsm or above. The weight refers to how much a ream of paper (500 sheets) weighs in pounds or, in modern terms, the weight of a square metre of a single sheet of paper given in grams.

This is not a definitive list of all the colours with these characteristics. When you have decided on which paint manufacturer you prefer it is worth writing to them and asking for a list of the characteristics of their paints. Otherwise you can go through your own palette and discover for yourself. Winsor & Newton give a list on their website.

## Brushes

There are two main shapes of brush: round and chisel tipped. The round-headed brushes are indispensable as they allow you to make a wide range of marks; the chisel-tipped brushes are more restricted as to the variety of mark that can be made with them so they are less useful.

The best quality brushes are sables, but they are very expensive and I would not recommend that you buy these if you are

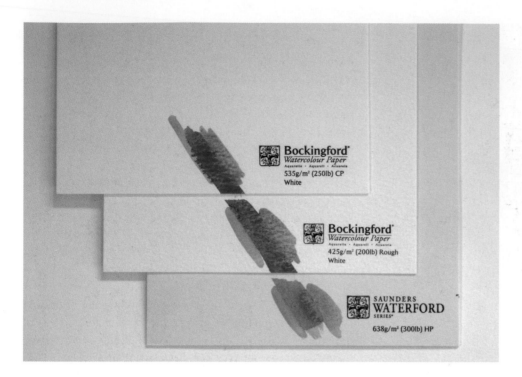

CP (cold pressed), Rough and HP (hot pressed) paper.

**Watercolour papers** are classified by their surface and come in three types:

- ■ **Hot pressed or HP** – This has a very smooth surface, good for detailed work such as botanical painting. It is made by passing the sheet through hot metal rollers.
- ■ **Not or CP** – Not pressed or cold pressed, which has a slightly rough or toothed surface, good for most types of painting.
- ■ **Rough** – This has a more toothed surface, suitable for bold and vigorous styles of painting. This paper has been pressed between the 'felts' on the paper machine and the roughness of the felt blanket is embossed into the wet sheet.

Buy individual sheets where you can until you find a paper that you enjoy using. When you find one that suits you, get a large pad that has been glued at the edges as this means you do not need to stretch the paper and it is ready for use immediately. A large pad is better than a small one as it allows you to work on both large and small paintings and you are less likely to cramp your compositions to fit the page. Large means A3 and above.

# MIXED MEDIA

As your work develops you may wish to broaden your interpretation of what can be used with watercolour to include a variety of other materials and techniques. Some of the things that you might like to include are described in this next section.

## Water-Soluble Crayons

These are crayons that can be used dry to give an ordinary drawn line in colour but can also be dissolved with water. This means that you can shade in an area and then, with a wet brush, turn it into a wash. You can also make stronger, darker marks by first dipping the tip of the crayon into water and then using it. They can be very useful for redrawing areas and for adding detail.

## Coloured Inks

Drawing inks give very strong, vibrant colour and can be used underneath watercolour or on top. Once dry they are permanent. Always wash your brushes out well after using these, otherwise the shellac that they contain will ruin them.

## Oil Pastels

These come in a wide range of colours and because they have an oil base they act as a resist to any watercolour going over the top. They can also be used to draw on top of dry paint.

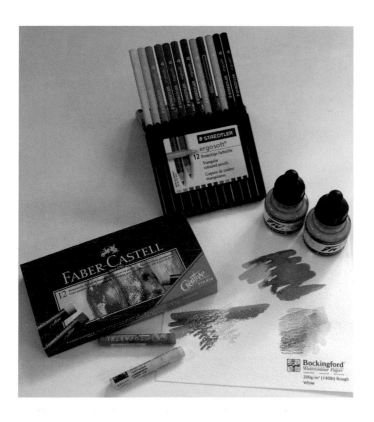

ABOVE: **Oil pastels, crayons and inks.**

## Masking Fluid

This acts as a resist to watercolour and keeps the paper underneath clean while you work across it. When the paint is dry the resist is removed by rubbing with a finger tip and the area exposed can then be worked into. Masking fluid is best applied either with the nozzle that comes with some of the containers, a sharpened stick or the wrong end of a paint brush. A brush can be used but, because the masking fluid contains latex, if it dries in the hairs of the brush it can be almost impossible to get out. Washing in warm soapy water immediately after use can help to remove it before it is dry.

## Marker Pens

These are available in a wide range of widths and colours and can be used for initial drawing or putting in detail on top of watercolour. Some pens are permanent and others will dissolve when wetted, which can give interesting results.

## Brushes

There are other brushes available to the painter, apart from the ones specifically designed for the watercolour artist. House-painting brushes are a cheap way of buying good-sized brushes for large work; Chinese brushes are also generally inexpensive and give a fluid, broad stroke as well as a decent point. Paint can also be applied with sponges, both natural and synthetic, sharpened bamboo sticks and even fingers.

## Other Papers

There are lots of wonderful papers on the market from all over the world. India, China and Japan all produce handmade papers in all sorts of colours and textures. You can probably pick up examples from craft fairs made by people local to you. Tissue papers also come in a wide range of colours and a variety of types. There is a paper called Straw Silk, which is a tissue paper with rice fibres in it. The fibres make the paper very strong and surprisingly soft to handle. Some tissue is colourfast while others will bleed when wetted, which can give interesting effects when mixed with watercolour.

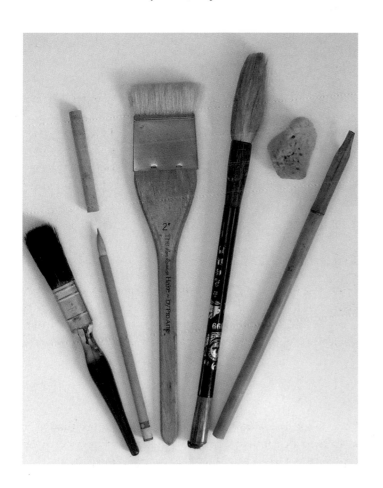

LEFT: **House-painting brush, Chinese brush, wash brush (or Hake), large Chinese brush, natural sponge and homemade bamboo pen.**

# MEDIUMS

Winsor & Newton have produced a range of mediums to mix with watercolour to give a variety of effects. These include: Granulation medium to give a mottled or granular appearance, Texture medium to give a grainy effect, *Aquapasto*, which is a transparent gel medium for reducing the flow of watercolour and gives an impasto effect.

## Gum Arabic

Mixing Gum Arabic into your paint will slow down the drying, giving you slightly longer to work on your painting, which can be useful with wet into wet techniques. It will also increase the transparency and gloss of your colours giving greater brilliance and luminosity.

Various paper varnishes are also available which enhance the colour of watercolour giving it greater brightness and intensity; they also protect the surface of your work.

# COLOUR MIXING

There are some basic pieces of information relating to colour mixing that are useful to know. There are three primary or first colours; red, blue and yellow. These are the colours that you cannot make by mixing other colours together. From these colours you can mix the secondary colours: purple from red and blue; orange from yellow and red, and green from blue and yellow. Putting any combination of the three primary colours together will give you the tertiary colours, which are various shades of browns and greys.

So, in theory, you could mix every colour by using different combinations and quantities of the three primary colours. However the primary colours that you can buy are not necessarily true primaries and have a little of another shade in them. For example, Cobalt Blue has a slightly green tinge, so is good for mixing greens but will not make a good violet or purple. Ultramarine Blue has a reddish tinge so mixes an excellent mauveish purple when joined with Permanent Rose or Alizarin Crimson but it makes a rather muddy green.

To make things more complicated colours vary from manufacturer to manufacturer, so it is very useful to go through the colours that you have chosen and find out what they will do for you. Make a colour chart by painting a small block of each colour and then mixing another colour with it and painting a second block and so on. This way you have a record of what your pallet will give you. Label the colours that you use so that you become familiar with their names and have a reminder of which colours you have put together. As you do this you will discover which of your paints are transparent and which are opaque. It is very useful to know this, and again it varies from

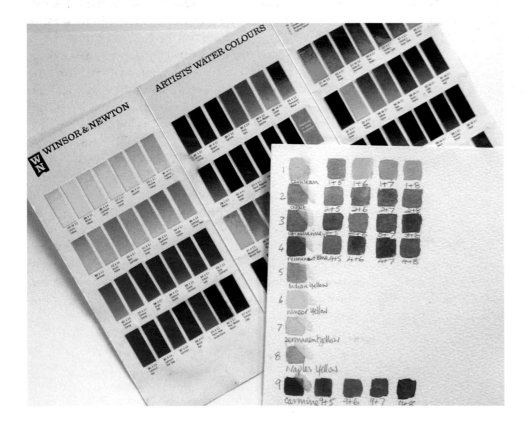

**Manufacturer's colour chart and part-finished homemade colour chart showing the washed-out corners.**

manufacturer to manufacturer, as some colours – such as the Cadmiums and Titanium White – can paint out a colour that has been put down in the wrong place. The opaque colours can also look rather heavy as they block out the whiteness of your paper, so they are best used sparingly. It is also useful to discover which colours will wash out and which will leave a permanent stain. To find this out, wait until your little blocks of colour are dry and then with a clean wet brush, try washing out one corner. There are ready-made colour charts available which give you most of this information, plus an indication of light fastness but they show only the individual colours, no combinations of colours.

This is a good exercise to do on a rainy afternoon with some music or a radio play going in the background.

## SUGGESTED PALETTE

It is useful to have two of each of the primary colours plus one or two of the secondary. A recommended selection would be: Cobalt Blue, Ultramarine Blue, Permanent Rose, Alizarin Crimson or Carmine, Indian Yellow, Winsor Yellow and Sap Green. You could usefully add to this: Blue Black, Olive Green, Permanent Mauve, Raw Sienna and Burnt Sienna but you could easily manage without. It is a good idea to start with a small selection and add to it when you find that you actually need another colour in order to achieve the shade that you are looking for. If you are using pans, put your colours into your box in a sensible order – all reds together, blues together and so on. This will help you to remember where each colour is as the colour is not always apparent from the appearance of the pan of paint. Then keep them in this order so you can go immediately to any colour as you want it.

## STRETCHING PAPER

You will need to stretch paper if it is less than 140lb/300gsm or if you are intending to use a lot of very wet paint with your composition. To stretch paper you will need water in a bath or a sink large enough to immerse the paper, gummed strip (not Sellotape or masking tape as these will not stick to a wet surface) and a board that is sturdy enough not to bend when it gets wet from the paper. Immerse the sheet of paper in the water so that it becomes evenly wet, lift it out by one corner and let it drain. Lay it on the board and glue down each side with a moistened strip of gummed paper. Make sure it is firmly stuck down all round both to the paper and the board and do not be concerned if it buckles slightly at this stage – it will flatten out as it dries. Leave it to dry completely and away from direct heat. Use the paper while it is still attached to the board that it has been stretched on.

There are pros and cons to stretching paper:

■ **Against:** by spending the time and effort stretching the paper you then become concerned about wasting all of it and become over-careful and stiff with your painting. It also means that you cannot use the other side of the paper if you go wrong to begin with.
■ **For:** you have a lovely smooth piece of paper which stays flat while you are working on it and with no buckling of the surface, mounting and framing the work is easier.

A good compromise is to buy blocks of paper that have been glued at the edges, thus holding the paper flat while you work. The sheet is removed when the painting is dry by sliding a knife or similar object into a small area which has been left unglued, running this around the edges and releasing the sheet.

There are any number of places where you can buy all the materials that you need. It is great fun and very tempting to browse through the shelves of your local art store but you can also buy online in many instances. See page 156 for a list of suppliers.

Another useful piece of equipment, apart from having your own studio where you never need to put anything away, is a portfolio. It is a good idea to have somewhere to keep your work, whether finished or still in progress, where it will stay clean and flat. Watercolours are very vulnerable until they have been protected by being framed or wrapped in plastic film.

A sketch book is another useful item as you can use it to record ideas, stick postcards of paintings that you have admired and make studies of still life set-ups before you start to paint.

Finally unless you are like Morandi, who used the same small group of objects over and over again, you will need some inspiration. A collection of fabrics and objects to start you off, supplemented by flowers, fruits and such like, is a very useful thing to have. It is a great excuse to visit car boot and garage sales, charity shops and antique markets.

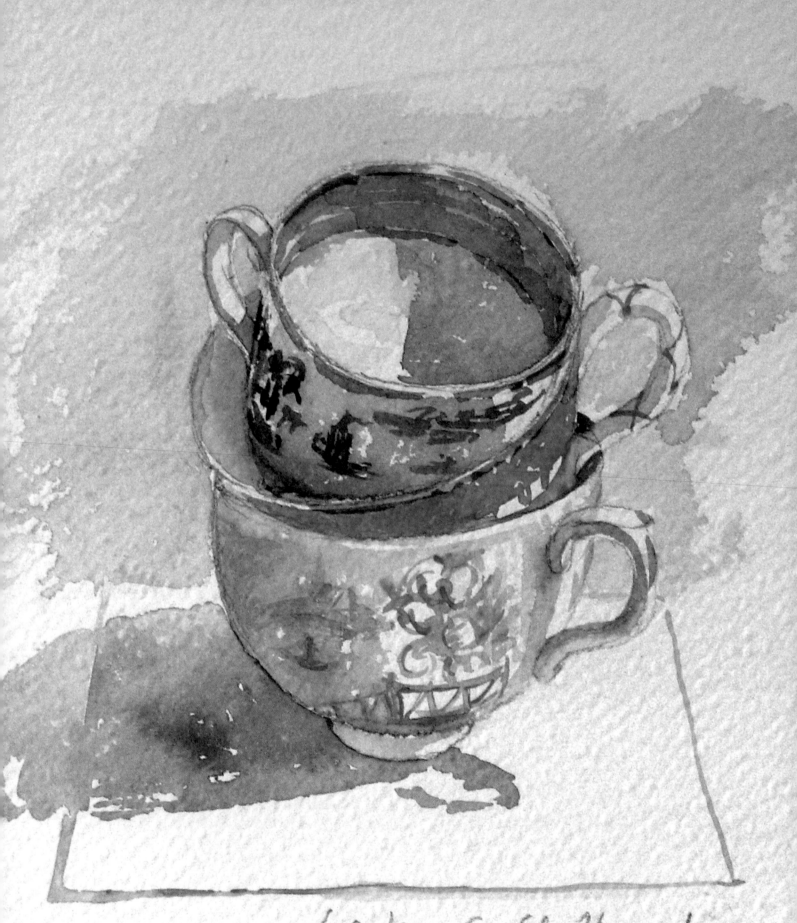

Lesley E. Hollands.

# WHAT TO PAINT

When it comes to choosing what to paint then the world is your oyster. Pretty much anything can be included, and probably has been included down the years, in still life painting. There is one very important rule to follow when making your choice of subject matter and that is, you must want to paint it. If you do not find it visually interesting then you are much less likely to produce an exciting painting or to enjoy doing it.

Inspiration can come from all sorts of places: something as prosaic as a freshly ironed pile of colourful clothing or the shopping unpacked onto the kitchen worktop can give you a starting point. Whatever it is, you must be the one to find it visually stimulating and try to decide what it is about the group that has inspired you. If you can work out what aspects have given you that itch to put brush to paper then you are more likely to capture the excitement. Sometimes it can be the strength of colours set one against another, possibly a very dark blue or red against a brilliant yellow. If you recognize this then you can avoid toning down those colours, making them 'safe' and losing the delight you first had in the idea for the painting.

Junk shops, car boot sales, and charity shops are all rich sources of all sorts of things that might inspire you to paint. Do not forget to look around your own shelves and cupboards as well. You might be surprised at what you can find once you start looking at things with the eye of a painter.

The supermarket, greengrocer or market stall can also provide rich pickings if you look at the fruit and vegetables from the point of view of colour and shape rather than just what is going into the next meal. Interesting packets of stuff can also be useful; again think about colour, pattern and shape rather

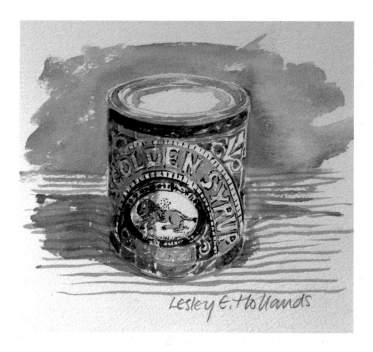

**Golden syrup tin on stripes.**

than content. A golden syrup tin with the green of the tin being picked up by a simple green and white striped cloth placed underneath it works well and makes a rather unusual subject for a painting.

Meal preparation can give some interesting ideas for different combinations of things. A new loaf of bread on a wooden board with a blue bowl of butter and a bread knife becomes an instant still life. Quite simple things can be good starting points for paintings. A bulb of garlic, especially those big French bulbs with pinks and purples in the skin of the cloves look great just

OPPOSITE PAGE:
**A stack of cups.**

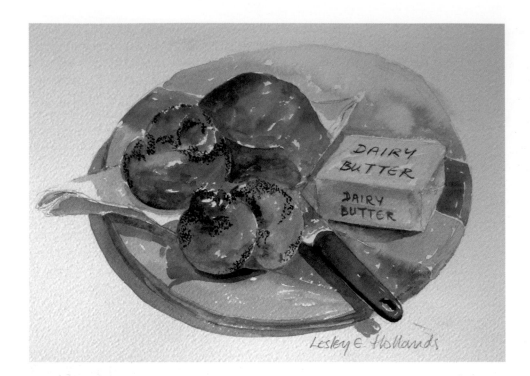

Bread and butter.

on their own with perhaps one or two cloves broken away from the main bulb. A pot of herbs on a window ledge with a little colour added in the form of a patterned tea towel or a couple of apples put next to it can look fresh and immediate. Vegetables and fruits brought in from the garden and laid on a sheet of newspaper or in a trug look great, especially things like onions with the green stems still on; big misshapen tomatoes in a range of stages of ripeness; apples in different sizes and shapes;

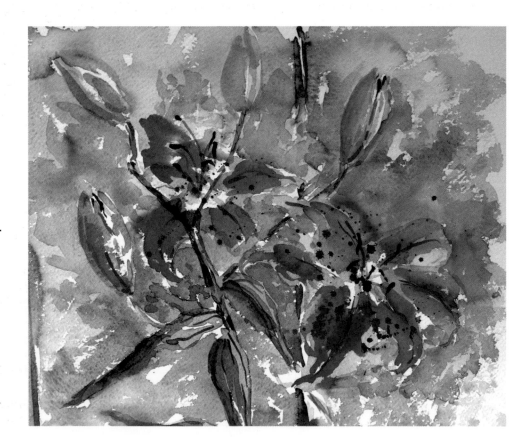

Pink lilies loosely painted.

strawberries or raspberries in a blue and white bowl all look simple but effective.

Flowers are another great source of inspiration and can be used very simply as either a small posy stuck in a jam jar or a large, formal and elaborate arrangement. Having an interesting array of jugs and containers to put flowers in makes the composition more attractive to paint. You do not have to stick to just one jug with flowers in. An arrangement with jugs and containers of different sizes, shapes and even more important, height can make a stunning painting. Having a small pot tucked slightly behind one of the larger ones so that it is can only just be seen looks good. Add fruit or other small containers and a white cloth and you have a fresh and vibrant painting to work on. Allow the flower heads to mingle as they emerge from their different containers to give a bold impression of colour and form.

Try different ways of lighting to produce effective and interesting shadows. Place the group near a wall and shine the light almost directly at it in order to get the flower shapes repeated on the surface behind. Put the light above the group and create a pool of shadow around the container. You could also create a small and simple flower painting by using a single bloom in a pretty container creating a tall, narrow composition. As an alternative you could do without the container completely and lay the flowers directly on the table, with a boldly-patterned fabric as a background into which the flowers would partly disappear. If you choose this way of working you will need to paint quickly as the flowers will not last very long out of water.

Wrapping the ends of the stems in wet cotton wool or paper towel can prolong their life. Flowers lend themselves to a variety of approaches to painting, ranging from the botanical to wet into wet, and of course the range of colours to choose from is almost endless.

How you put things together is also important. Try out different ways of arranging the objects you have chosen. Three cups stacked inside each other, comprising different shapes and patterns, becomes an unusual composition for a painting and is also quite a challenge for the artist drawing them.

A row of objects can look appealing, especially if they have a theme of some sort to hold them together. A row of apples or pears, each with a slightly different shape and colour, can look very bold when lit from one side quite low down so that the shadows connect the objects. The row does not have to be horizontal. A vertical column of objects can present great

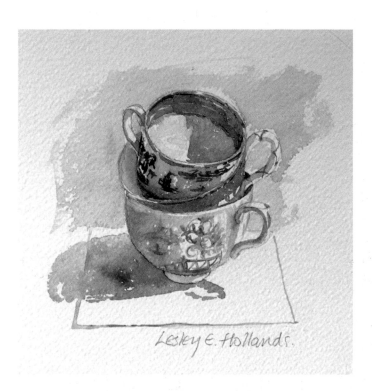

A stack of cups – a challenge both to draw and paint.

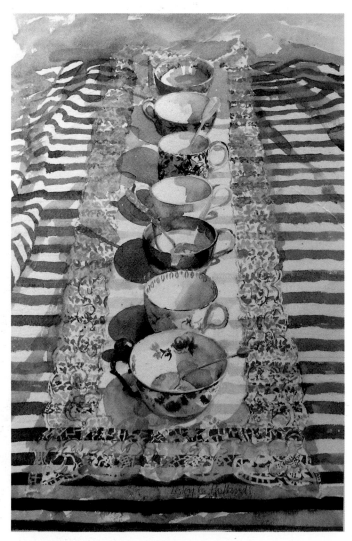

A row of cups – a difficult piece of perspective drawing but an interesting composition.

challenges with perspective but give an unusual and dramatic composition. For example, a row of cups, all slightly different, arranged on a narrow, lace-edged cloth in a vertical format, makes a delightful painting (*see* page 21).

When putting together a composition, try to include things that are not immediately obvious to the viewer. A painting that is not seen all at once – one that the viewer returns to and then finds more to look at – is a good painting. Something a little quirky and fun can add an extra dimension; for instance, in a row of apples the addition of a snail shell, just tucked a little behind one of the fruits, can give that additional something. Small wooden animals, glass marbles or beads can all be useful additions to enhance a composition.

Your personal viewpoint of your composition can also make quite a difference to the look of a painting. Arranging your group on a cloth or rug on the floor so that you are looking down on it gives a totally different perspective and can transform an arrangement. This view also solves the problem of what to put in the background as the cloth or rug serves this purpose and you paint what you see. Even placing your composition on a stool or chair so that it is a little lower than usual can improve the viewpoint, or standing up to paint, rather than sitting down, can also be beneficial.

Placing your group against an interesting background can also help to improve the composition. A window ledge with a view into a garden or street – or even just the sky – can add depth and distance to the make-up of a still-life group. Putting objects on a table outside in a garden, balcony, backyard or patio gives a wider range of views and aspects to include. Or the table could be set up as if for a picnic, with a basket of food, plate, cutlery, a bottle of wine and suchlike. Alternatively, you could show gardening tools and some flowers or vegetables resting on an apron or piece of newspaper. The range of objects to use in this situation is as limitless as your imagination.

Make a viewfinder by cutting a rectangle out of the middle of a piece of stiff paper or thin card. Use this to look at your surroundings and discover the many ready-made still life groups that are there.

Lighting can also play a very important part in setting up a composition. By altering the lighting you can change the whole mood of the piece, taking it from bright sunshine through to soft candlelight. The angle of the light source also changes the shadows quite dramatically. Try putting together a still life and lighting it with something adjustable such as an anglepoise lamp or even a bright torch. Start by shining the light from a very low level, which will give you long shadows that will fall not only on the table surface but onto other objects as well. This angle connects the objects. Then move the light upward, looking all the time at how the shadows are changing. When the light gets to the top the shadows are greatly reduced and will be pooled below the objects, possibly not touching each other at all. Now put the light behind the group (this is called *contre jour* or 'against the light'), and see how totally different everything looks. The shadows are coming towards you and the objects are

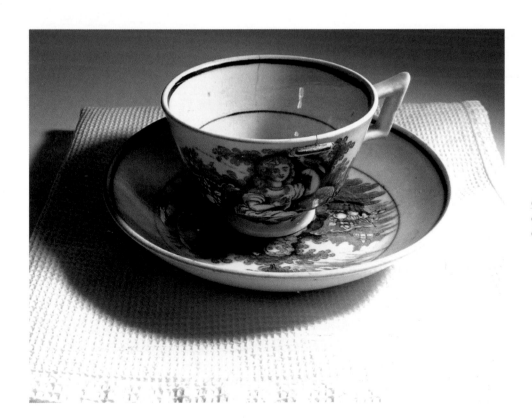

**Cup and saucer lit from a low level, giving useful shadows in the cup and cast by the saucer.**

in near silhouette. With this set up the shapes of the objects and the spaces between them become even more important. An advance on this view would be to place a venetian blind behind the objects, fixed to the back of a chair or an easel, and the light shone through the partially-opened slats. This gives the most interesting consequence of striped bands of light falling across the group. Again, this is quite a challenge to paint but very rewarding if you can carry it off.

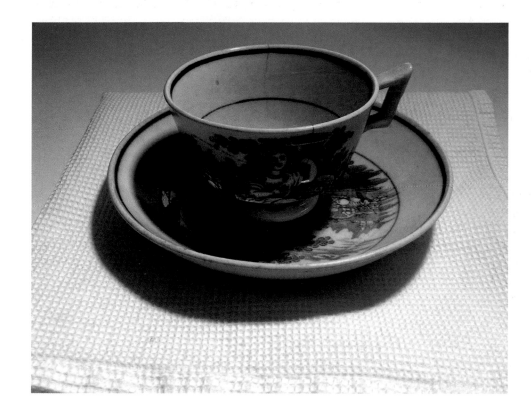

Cup and saucer lit from above – note the less interesting pooling of the shadows.

Cup and saucer lit from behind, which gives some interesting effects from the shadows being thrown forwards.

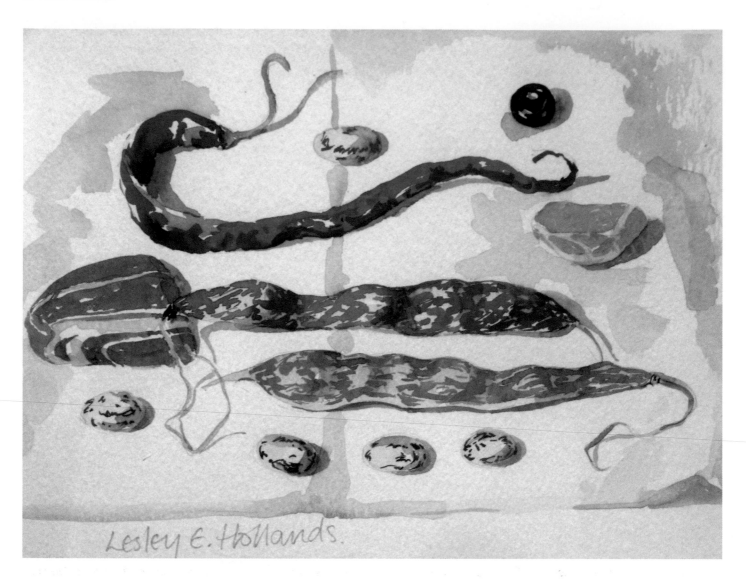

**Home-grown beans.**

Look at the work of other painters, not limiting yourself to watercolour or still life. There is a long tradition of painters being inspired by the work of other artists and reinterpreting it. The Dutch and Flemish schools had a tradition of very fine still-life paintings in oils, often very elaborate with piles of fruits and vegetable, flowers and even tables groaning with arrays of meat and fish. One wonders how often they had to be changed before the painting was finished or perhaps they did not mind the smell! Many painters, who were not using still life as the main theme of their painting, would include a still life as part of the composition. It is fun to look out for these when visiting an exhibition or gallery. Books, postcards and birthday cards can all give you ideas for your own work. It is best not to try and copy these (some will be in copyright anyway) but to put together your own group based on what has inspired you in the other artist's work.

To sum up: keep an open mind about what to include in your paintings, use your imagination and do not be afraid to do something out of the ordinary.

## DRAWING

Drawing is the starting point for many works of art. It can be used as a sort of shorthand to quickly put down an idea, capture an image or a moment. It can be used to explore fully an idea for a still life and if you are using pencil it is then easy to change and adjust your work until it is just as you want it. Different approaches can also be worked through quickly and easily with a drawing and decisions can be made before committing yourself to paint. In the pencil drawing on page 25,

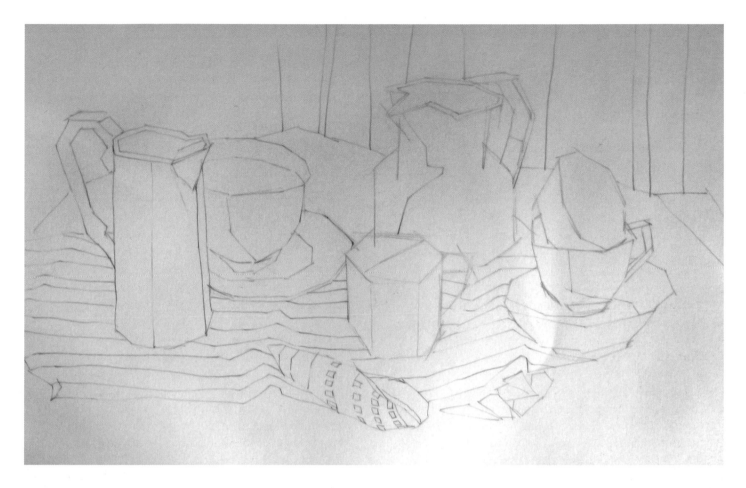

**A semi-cubist drawing.**

a still life has been interpreted in a semi-cubist manner with curved lines being straightened to give an angular effect to the composition.

Pencil is not the only thing to draw with; a brush can be used to create fast, fluid lines that are expressive and lively; coloured pencil crayons can give a more considered approach and if you use the water-soluble variety they are then readily incorporated into your painting; black pen can give a bold, dramatic structure to a watercolour, with strong, clean lines that can hold a composition together (as long as the ink is the sort that does not run); felt tip pens can give a lively, colourful effect and have the advantage of being inexpensive and readily available.

Making drawings as a preparation to still-life painting is mostly about good observation. Technique comes into it, but first and foremost is seeing what is really there in front of you, not just what you think is there. You need to look with a fresh eye, putting aside all your preconceived ideas, and be quite analytical and objective. It is all too easy for your brain to lead your eye astray. Relative size is a good example of this and can be hard to get right. Place two objects of a similar size in a still life, one further back than the other and there is a tendency

to draw both the same size. In reality, the one further away appears smaller, even in the small space of a still life because of the effects of perspective. A good way of tricking you brain into seeing things as they really are is to imagine that you have never seen that object or group of objects before. To aid this, try holding up a mirror and looking at the group reflected in that.

The more you draw the better you will get at doing it and the easier it will become. You will become more accurate and develop your own distinctive style but this will only happen if you stick at it and practise; just thinking about it is not enough. If you can draw from observation for only fifteen minutes a day you will be amazed at how quickly you improve.

## USING A CAMERA AS AN AID TO PAINTING

A digital camera can be a very useful aid to painting on a number of counts:

■ It can help you to see a composition clearly and make necessary adjustments before starting on a piece of work. Just changing your viewpoint slightly can make a surprising amount of difference to the composition, as can be seen in the photographs on pages 22 and 23.

■ You can enhance, or even change, the colour by changing the settings on the camera. Going from bright daylight to interior electric light can change the colour tones from cool to warm quite dramatically and you can then decide which you prefer or which would be most appropriate for the painting you are about to start on.

■ A camera allows you to home in on an area of your still life set-up and crop it as you wish. You can also look at areas in close-up to aid you with the drawing. If you feel your composition is not quite right, pinning up your drawing and the photograph side by side can help you to spot where you are going wrong.

■ A camera can be used to capture a not-so-still, still life – for instance a snail crawling across a leaf, a frog or a dragonfly. If your flowers are beginning to wilt, a camera can hold them until you have time to complete the painting. Incorporating an animal into a painting can be difficult as they rarely want to sit where they are put and then they do not stay still for more than a short time. Taking a photograph of the cat, dog or whichever

creature you wish to use and then working from this as well as from the still life makes the inclusion of living things much more feasible. In order to work out where the shadow would be cast by and on the animal, try to take the photograph with the same light source as the still life. Putting something into the still life to represent the animal will help you to get the scale right. A carrier bag stuffed with paper and pushed into a rough cat shape for instance, can help you to see the effect the animal would have on the rest of the group.

■ You can take a camera out with you and snap any images that appeal to you and then you can recreate them later. The composition of a beautiful landscape can be captured in a photograph, which can be used to reinvent the arrangement at home but by using fabrics and objects to replace hills, trees and buildings.

■ It is useful to keep a record of your work and a camera plus a memory stick makes this an easy thing to do. It is good to see how you have progressed with your work and as you begin to sell, it is pleasing to be reminded of paintings that have left you.

■ Your paintings can be downloaded and used as a screen saver or desktop wallpaper or you can have them printed as the next family Christmas card. If you get to the stage of setting up your own website then a digital camera is invaluable.

**Sleeping kitten.**

Comfortable cats.

Cat on a patchwork quilt.

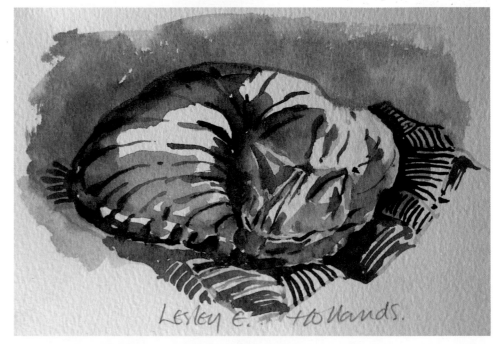

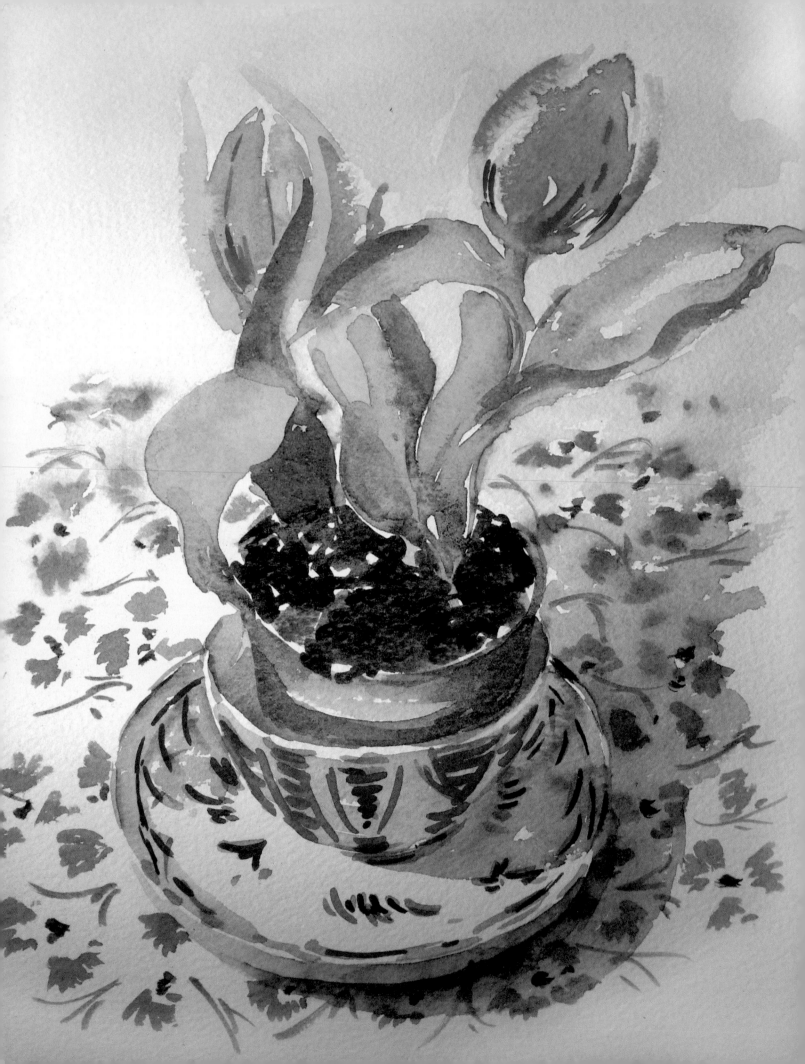

# GETTING STARTED

If you are a complete beginner or have not painted for some time then the following exercises will help you get started. The exercises are planned to help build up your confidence and therefore your enjoyment of painting or, of course, to reignite the pleasures to be gained from letting paint flow and objects emerge from the washes of colour. As you relax into the painting your enjoyment will come through. Do not worry about going wrong; it's only paint and paper after all and many supposed mistakes can be rectified or turned to your advantage.

## EXERCISE: LEMONS

A lemon is a good way to start as it has a simple and easily recognized shape, which is not difficult to draw. It also has a straightforward colour, which is easy to mix.

First choose a lemon with good shape and colour and place it on something white: a tea towel, kitchen roll or piece of fabric will do. Then light it by placing it by a window or a lamp so that you have some strong highlights and shadows. You are now going to try several different techniques.

## EXERCISE 1

Make yourself comfortable, with all of your equipment within easy reach. Ensure that you can see the objects that you are about to paint and your paper without having to swivel around.

**OPPOSITE PAGE:**
**A pot of tulips.**

**Lemon lit from low down – note the colours in the shadows.**

Ideally you should just have to move your head up and down with the minimum of movement and see the still life and your work.

Put out some Winsor Yellow, Indian Yellow and Cobalt Blue on your mixing palette. Draw the lemon lightly using a B or 2B pencil. Mix a range of yellows and try them out on a spare piece of the same type of paper as you are working on. You could just use the edge of your present piece. Using the larger brush, wet the lemon drawing and drop into the wet surface some of your mixture of the two yellows. While it is still damp, blot out the area of the highlight with a piece of screwed-up kitchen roll.

Mix a little blue with the yellow on your palette and add it to the lemon to create the shadow on the fruit. The edge of

First wash with the highlight blotted out.

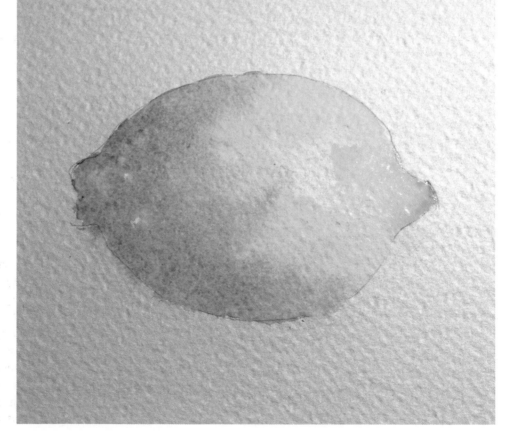

The shadows are run into the damp paint to keep the edges soft.

**Completed lemon – note the darker shadow immediately under the fruit, which helps to anchor it to the table surface.**

the shadow should be soft to indicate that it's a curved surface. Tease out the edge with a damp brush if it looks as though it's going to be too harsh. Wait for the lemon to dry then start on the cast shadow.

If you look closely you should see that the shadow is darker immediately under the fruit. Now look for colour in the shadow; you may see it as grey, but what shade of grey? Does it tend towards blue, mauve or green? Compare the intensity of the cast shadow with the shadow on the fruit: is it lighter or darker?

Now mix the colour by putting together different combinations of the colours on your palette. Paint a little onto a spare piece of paper of the same type as you are working on and hold it against the shadow. This helps to train your eye and your mixing abilities. When you are happy with the colour, place it where the shadow should be; don't make it too large. Reduce the size if it looks as if it's going to be larger than the lemon and soften the back edges with a brush dipped in clean water. By softening the edge furthest away you will help to make the shadow recede and lie flat. Now, with a little more of the shadow mix, darken the shadow immediately underneath; this will help to anchor the lemon and make it look as if it's sitting firmly on the table. If the original colour on the lemon has sunk (become paler), or now does not look as bright as you want it

to, don't be afraid to put another wash of pure yellow over the whole of the lemon, blotting out the highlights again.

## EXERCISE 2

This time you are going to use a slightly drier brush and drag the paint over the drawn shape of the lemon, using the side of the brush as well as the tip, leaving highlights as you go. Practise dragging on a spare piece of paper so that you learn to judge the right amount of water needed to give you this effect.

This method works best on a fairly grainy or rough paper with some 'tooth' to it.

Continue as in the previous exercise, adding shadows to the lemon while the paint is still damp but this time paint the shadow cast by the lemon before the paint on the lemon is dry. You will get a blending of the colour here and a little running together of paint. This effect is very typical of what watercolour can do and once you have learnt to control it you can use it to your advantage in many different painting situations. If the shadow has run too much then wait for it to dry and tidy up the edge where the lemon meets the shadow with a little darker colour. The shadow is usually darker immediately under the object casting the shadow.

A dragged wash leaving lots of flecks of white paper showing.

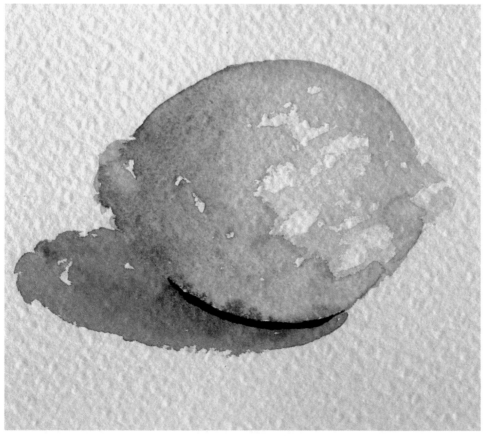

Completed lemon – note the range of colours both on the lemon and in the cast shadow.

## EXERCISE 3

This is a much looser approach to painting and gives a softer effect.

Don't draw your lemon but apply a broken wash to an area much larger than that of the lemon. Use a light clear yellow and leave plenty of white areas. Too much white can be covered later; it is more difficult to put it back if you have lost it. While this wash is still wet apply another wash of a slightly darker yellow in the shape of the lemon, again trying to keep areas of white where your highlights are. Now take some shadow colour and lay on a third wash to indicate where the shadow is. Let everything dry and finally paint in the cast shadow.

**LEFT:**
**A broken wash.**

**BELOW:**
**The completed lemon – this approach gives a much softer effect.**

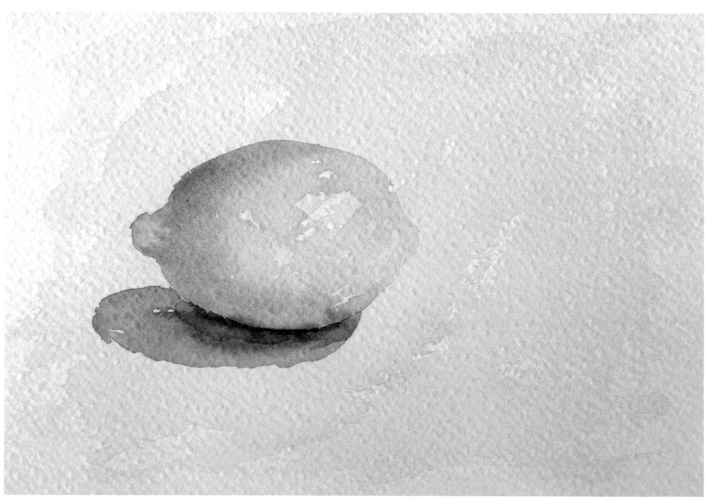

## EXERCISE 4

This is a much more controlled way of working and involves looking very carefully for subtle changes in colour in the objects that you are painting.

Draw your lemon again and this time mix a range of yellows on your palette in small pools of colour. Now add some shadow colours to this range. You should end up with around six to eight shades of yellow and four or more shadow colours. Try the colours out on a piece of paper of the same type as you are using and wait for them to dry. You can then assess whether the colours you have mixed are strong enough to give you the right intensity of colour. Don't forget that with this method of painting you are not building up the colour in layers but aiming to get just the right colour and tone for each brush mark.

You are going to apply the paint in small areas, putting the right shade of colour down in the right place side by side rather than using overlapping washes as in the previous exercises. Compare one area with another as you work to ensure the right tone or depth of colour for each mark. This is a painstaking way of working but it is a very good way of training your eye to see colour really accurately. Continue building up the colours, frequently stepping back to make sure that you are putting the correct colour in the right place and adjust any that are not quite accurate. To adjust the colour either put another layer of colour on top or, with a clean wet brush, wash out as much of the colour as you can and then, when the area is dry, reapply the correct colour.

You are now going to learn how to paint two very different surfaces that are often found in still-life compositions. The first of these is glass.

## EXERCISE: CLEAR GLASS

When painting clear glass the main things to remember are that you are painting what you see through the glass and what is reflected on the surface rather than the glass itself. By doing this you will avoid making the glass look like pottery.

Start by choosing a fairly simple shape, a jam jar perhaps, or a plain wine glass – not cut glass. Next place something in the glass object; flowers perhaps or even a spoon or paintbrush would do. Place the glass on some fabric; stripes work well, and also make it easy to see the distortion the glass makes, and light the group clearly from one side.

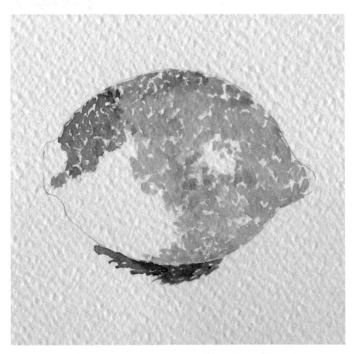

**A totally different appearance is achieved by using this more painstaking method of applying the paint.**

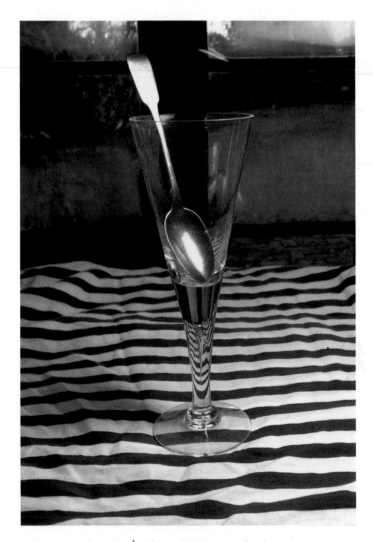

**The glass with a spoon on a striped cloth.**

The first thing that you are going to do is look hard at what you have in front of you. Notice how things are distorted when seen through the glass. If you are using flowers in water you will get further interesting effects caused by refraction – the way that light is bent when it passes through water. Do not be afraid to put down exactly what you see. Look for colours reflected in the surface of the glass. These are often difficult to see but moving your head so you are looking from slightly different angles can help you see the subtle changes in colour. Look for changes in colour as well as distortion of the pattern where the fabric is seen through the glass. There should be shadows cast by the glass but not a great deal to see on the glass itself.

Next, you are going to draw the glass and whatever you have put in it. Keep your pencil marks light so that they do not interfere with the finished work. Now mix a range of pale blues and greens and test them on a spare piece of paper. Then mix the colours for the rest of the objects.

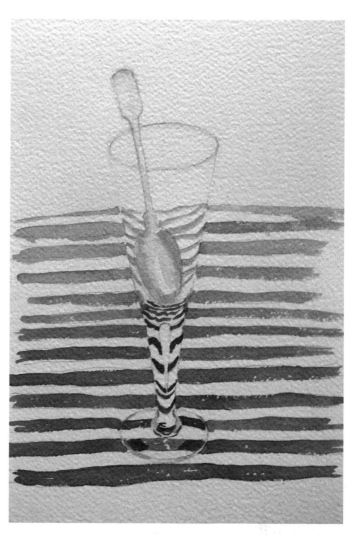

**The stripes are painted with a darker colour at the front, gradually getting lighter as they go back, which makes use of the effect of tonal recession.**

Looking hard at the glass; place some colour where the glass is thickest – this is usually the base, rim and neck. These darker marks should be at the front, which will help bring the areas forward. Now work on the object in the glass, looking especially for changes in both shape and colour. Move on to the fabric and what you can see around the glass – by putting this in now it will help you to define the edges of the glass without actually painting them in.

The next step is to stop and look.

It is very easy to go too far too fast when trying to capture the look of glass. Prop your work up, step back from it and assess which areas need more paint. At this stage you will probably need more indication of water level (if you have water) and a suggestion of shadow on the side away from the light. Put in any shadow cast and remaining fabric seen through the glass.

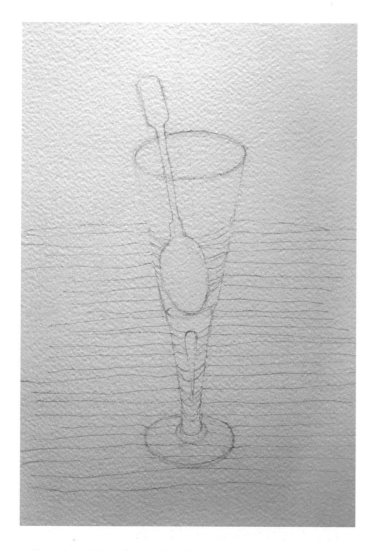

**Drawing of the glass and cloth – note the distortion of the stripes where they are seen through the glass.**

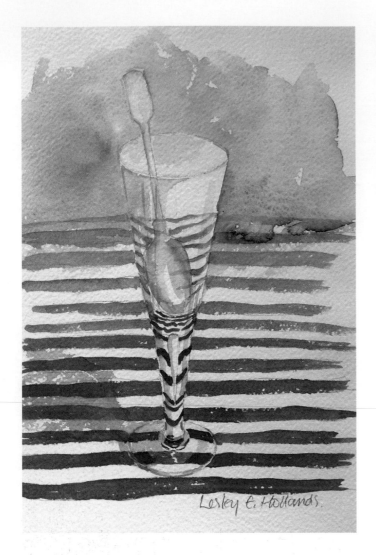

**The completed painting with a much lighter background wash than in the photo, which helps to keep the bright fresh feel of the composition.**

You should now be nearly finished but with lots of unpainted areas. Stop and look again at what you have and make a final assessment of anything else that needs to be done. Put in the finishing touches but do not overdo it.

## EXERCISE: A PATTERNED CUP

The next exercise is to draw and paint a piece of ceramic with a pattern on it.

Choose a cup that you like, preferably one with a simple circular rim, no flutes or odd shapes. Place the cup in front of you with a good light on it. There should be shadow and light on the inside of the cup and a cast shadow.

With a round object such as a cup or a vase you have the

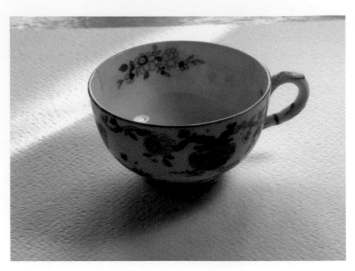

**A patterned cup lit to give a useful shadow on the inside and an interesting cast shadow.**

added problem of drawing the ellipse (the foreshortening of a circle due to perspective). When you are looking at a round object you know that the top and bottom is a circle but when you look at them from an angle it appears to be an oval and if you hold the object up at eye level the circle appears as a straight line. The further the circle drops below eye level the nearer it will appear as a circle again. When you are drawing more than one ellipse the bottom of the object will be more rounded than the top because it is nearer to the view that gives you the full circle again.

When drawing the ellipses it is important to get the relationship between the depth and the width right. In order to do this, measure the depth of your cup by holding your pencil at arm's length (keeping your arm straight to avoid changing the measurement), lining up the top of your pencil with the back of the object and placing your thumb on the pencil to mark the front of the object. Keeping your thumb in this position and your arm straight, turn the pencil horizontally and see how many times the depth measurement goes into the width. It will probably be around two to two-and-a-half times.

Now mark on your paper where you want your image to be and make two small dots or dashes to indicate the depth of your cup. This will not be the same size as the measurement that you have just taken because, if you did so, it would make the image very small. Using the distance between the two marks you have just made indicate with two more marks where the width of the cup should be. So, if you measured that the depth went into the width two and a half times then you would take the depth that you have just marked on your paper and multiply it two and a half times. Draw in your ellipse with a nice smooth curve, avoiding any resemblance to a lemon. To aid this, first draw in a

curve at either side and then join these up with the marks front and back.

Draw the rest of the cup, again using your measurement of the depth as a guide as to where the base of the cup should come. Notice that the bottom ellipse is more curved than the rim. To help you observe this more easily place a straight edge, such as a pencil, on either side of the base of the cup and look at the shape between. Draw in the bottom of the cup but don't stop at the sides, continue as though the cup were see-through and draw the whole ellipse. This will help you to achieve the correct curve. When you are happy with the drawing of the base, rub out the bit that you don't need and step back from your work to check that all is well. The final parts are the handle, rim and pattern. The rim, although only a very narrow strip, is most important as it indicates the thickness of the china. If you lose this edge then the cup will look wafer thin. If that does happen do not despair as there are ways to remedy the mistake, which will be covered shortly. The rim of the cup has its own perspective and will appear wider at the front and sides and narrower at the back. Draw in the rim so that you do not lose it when you come to paint in the shadows.

The handle can be quite difficult to draw correctly and if you find it very awkward then just turn the cup around so that the handle sticks out at the back and you only have the top to deal with. Look at the space inside the handle and where the handle meets the cup at the top and bottom. Mark these two places and draw the basic outline of the handle. The handle is made up of four main areas, the top, the inside, the side and the space between it and the cup and all these need to be right. It can help to simplify the shape by drawing it as though it were a rectangle or square and then draw the more complex shape inside this.

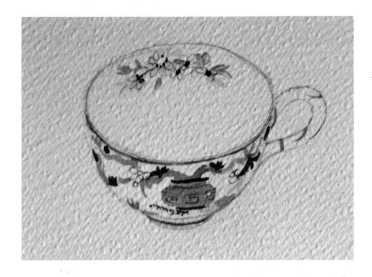

**Cup with pattern – make sure the design follows the curved shape of the cup.**

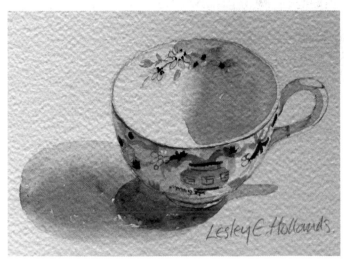

**The completed cup – take care to leave the rim of the cup white and do not worry if some of the pattern runs.**

When the drawing is complete and as good as you can get it start to paint.

If the china is white then a blue tone for shadow will work well. Look at the shadows both inside and outside of the cup and cast by it and look to see if there are any variations in the colour. Paint on the pattern and make sure that it is following the curve of the cup. The pattern will look foreshortened or squashed up slightly as it goes around the side and out of sight. Put in the shadow inside the cup, softening the top edge where it follows the interior curve and looking at the angle where it goes down to the bottom. Be aware of the all-important rim and put in a wash of colour for the shadow on the outside. Again, make sure

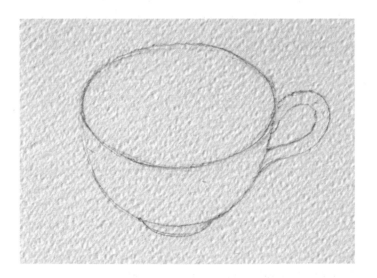

**Drawing of the cup with careful attention being paid to the top and bottom ellipse and the handle.**

that the shadow fades out gently as it moves around the curved surface. Do not be too concerned if the pattern runs when you put the shadow over it. A little blurring can be attractive and if it goes too far you can crisp it up again when the wash is dry. Finally, deal with the cast shadow. If you look carefully you will see that the shadow is darker up against the object casting the shadow, and as it moves further away it gently fades out. Compare the cast shadow with the shadows on and in the cup. Is it darker or lighter? Does the colour change? How far round the base of the cup does it go? Is the front edge of the shadow more defined than the back? When you have answered all of these questions then put in your shadow wash.

Take a break and then look again at what you have achieved and make any adjustments that are needed.

If you have lost the highlight on the rim then either try washing out the line using a fine brush and clean water or put it back in with Titanium White. Titanium White is far more opaque than Chinese White and less heavy and thick than gouache.

## EXERCISE: WHITE FLOWERS

This is a useful exercise to do as it helps you to consider the background as part of the drawing and a way of creating negative shapes, which will be the flowers.

Choose simple flowers for this; white daisies or single chrysanthemums work well as would sweet peas. A bolder statement could be made by using white lilies but avoid fussy and complicated shapes such as roses. It does not matter what sort of container the flowers go in as you are going to concentrate on the blooms not the pot. Put a light on the group to illuminate it from above and to the side.

Draw out the flowers, being particularly observant of the varying angles and lengths of the petals. Look for the shapes of the spaces between the flower heads and the angle of the centres. Draw in the stems and indicate lightly where the leaves are going to go. You do not need to include all of the blooms in your bunch; selecting just three can make an attractive composition with the advantage that it is easier to do, so simply choose the ones that suit you best.

Saunders Waterford Rough 140lb/300gsm has been used for this study with the following colours: Indian Yellow, Winsor Yellow, Cobalt Blue, French Ultramarine and Cerulean Blue if you have it, plus Sap Green.

You are going to start by putting in the centre of the flowers, in this case shades of green going through to yellow at the edges. Before doing this, make a final check that the centres are the right distance away from each other and adjust if necessary. Keep the paint broken in texture, leaving flecks of white paper

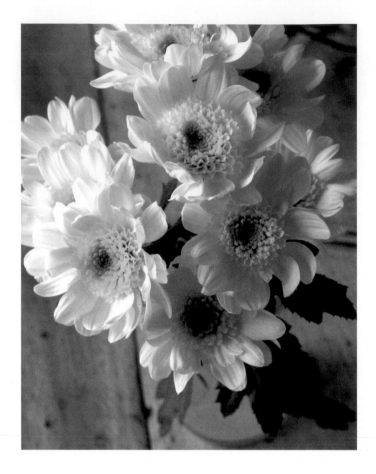

**White flowers viewed from above.**

showing, so that it suggests the uneven surface of the centre where the seeds would form. Dotting in the colour with the point of your brush works well.

The next thing to do is the background and here you are going to use a range of blues with a little green added. These colours set off the white petals very well, adding interest into the background, without being too dominant and keeping the whole colour scheme fresh. Make one side of the background slightly darker than the other to give the impression of light falling on one side. Paint fairly carefully around the drawn-out petals and again do not fill in too much. You are aiming to create a sparkling effect by leaving the flecks of white paper showing. Let this dry.

The petals are the most difficult part as it is all too easy to overdo it when painting them. Avoid outlining the petals with a line of paint. The background being there should be enough to give you the shape of the flowers. Mix up a very pale shade of Cobalt Blue and another of Sap Green with a little yellow added to make it quite a sharp colour. Try out the colours and let them dry; they must be very pale indeed. Look at the flower heads and try to see where there is shadow on them. The petals are likely to be casting shadows on each other and where the

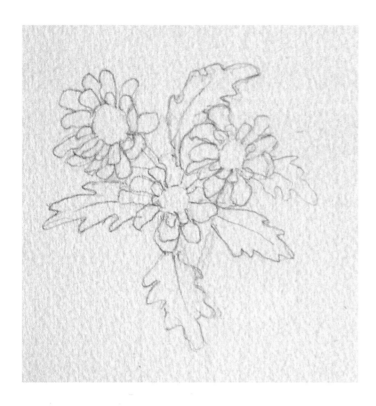

Drawing of the flowers with some of the blooms left out in
order to simplify the composition.

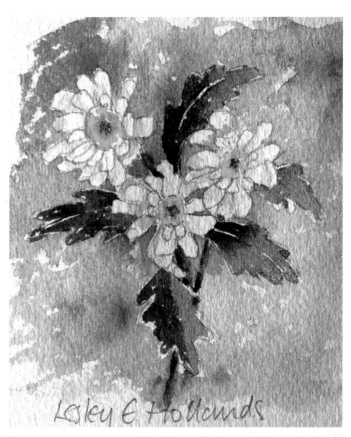

Lesley E Hollands

The finished painting with some good strong colour in the
leaves, which helps to show the fresh delicacy of the flowers.

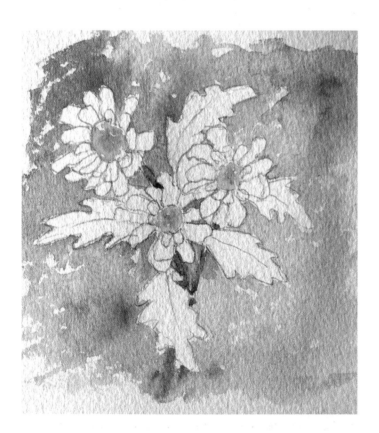

The centres and the background are painted in, which makes
the flowers stand out.

petals grow forward from the centre there will be a shadow on
the inside of the flower. Start to put in the shadows, beginning
with the area around the centres, using the green colour. It will
tend more towards a green here because of the reflected yellow
from the centres. As the shadow moves away from the middle it
will tip more towards a blue shade. Put the minimum of shadow
in, you need to indicate that the flowers are three-dimensional
but still keep their feeling of delicacy.

When the flowers have begun to take shape put in the stems
and the leaves. The stems should have a light and dark side to
make them look round and the leaves need a range of shades of
green to stop them looking flat. Step back from your work and
decide whether any more colour is needed on the flowers and
put it in if it does. Finally, soften some of the edges of the petals
furthest back in the composition by running a damp brush
along them or wetting them slightly and dropping a little of the
background colour in. By doing this you will give the composi-
tion a greater feeling of depth.

You should end up with a delicate, fresh painting of flowers
with an interesting background. Having completed these exer-
cises you are now ready to take a step forwards and start on a
more complex still life.

# EXERCISE: A SMALL GROUP OF OBJECTS

Choose three or five objects. An uneven number is more pleasing to the eye than an even number. Include something organic, the lemon again possibly, something inorganic and hard such as the cup, and some fabric. Arrange the objects in a way that is pleasing to you but avoid the pitfall of having too much space in the background by putting in one object that is very much taller than the rest. A triangular arrangement gives a strong composition. Light your group and adjust the angle of the light source to give some interesting and useful shadows. The shadows help to show where your objects are in space and also indicate shape and form. For instance the shadow inside a cup shows that it is hollow, the shadow cast shows that the object is sitting on a surface and not floating in the air.

Here a simple group, which includes a cup, a lemon, a glass vase and some striped fabric, has been put together and lit from a fairly low angle which gives some long, connecting shadows.

Look at the spaces between the objects, the negative space, as these are important and can be used to lead your eye into the composition. When you are happy with your arrangement, go away from it for ten minutes or so and come back and look at it again with a fresh eye. Make any final adjustments and then start work. Sketch out your composition lightly on a piece of paper slightly larger than you think you will need. It is far better to have too much space than to cramp your drawing and you can always use extra space in the margin to test out your colours. Do not put in a lot of detail at this stage.

To help you see things clearly use your pencil as a measuring stick, check the heights of one object against another, how far forward or back the objects come and the distances between. By doing this you are training your eye to see things as they really are, not as you think they are. Making your drawing light has enabled you to rub out any parts that need correcting without making the paper messy and by not putting in a lot of detail at this stage you can avoid the temptation to keep your hard work and put up with it, even if it is wrong. When you are sure that your basic drawing is correct put in some detail, make a final check and you are now ready to paint.

Put out your equipment, making sure that you are comfortable and everything is to hand. Look first at the shadows and try to see how the colours change depending on where they are falling. The colour in the shadow is affected by many different things including type of light, closeness of light source, reflected colour from other objects and of course the colour of the object itself. Observe how the intensity of the colour changes from place to place. Ask yourself: is it darker in the cup or beside the cup? Is it darker still underneath the cup and the other objects? Do the shadows appear lighter as they get further away? When you are satisfied that you have really seen what is in front of you, start to apply colour.

Fabriano Artistico Not 140lb/300gsm paper has been used with the following colours: Winsor Yellow, Indian Yellow, French Ultramarine, Cobalt Blue, Carmine and Sap Green.

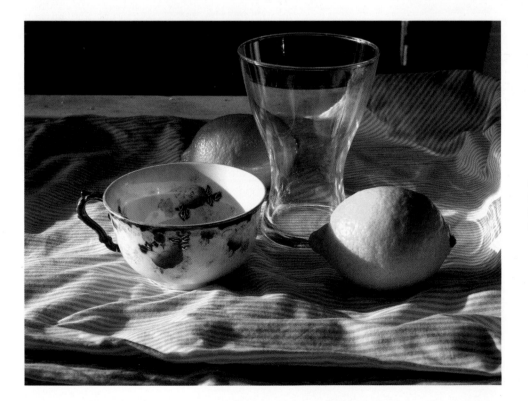

**A simple still life group with the light casting some useful shadows in the cup and on the lemon, which helps to show the shape of the objects.**

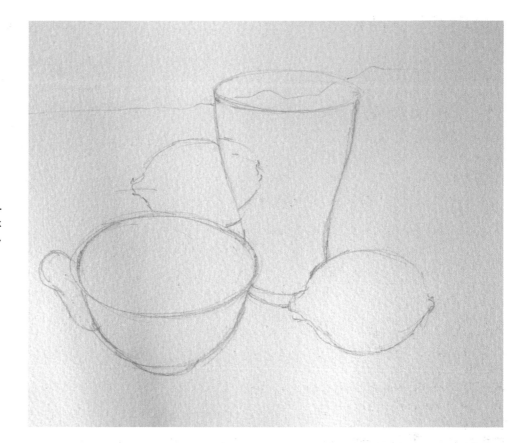

An outline drawing of the group –
make sure that the lemon at the back
is smaller than the one at the front.

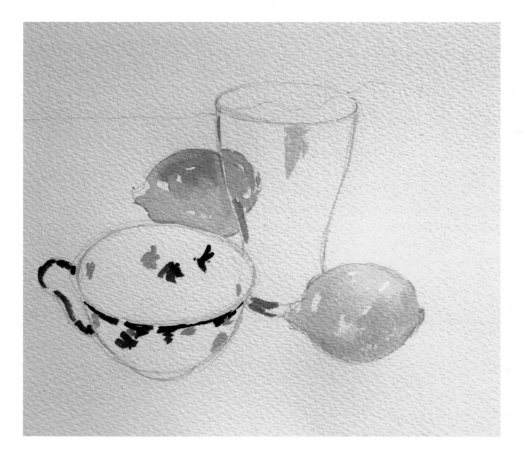

The first colours are laid in, making
use of the reflections and distortions
in the glass.

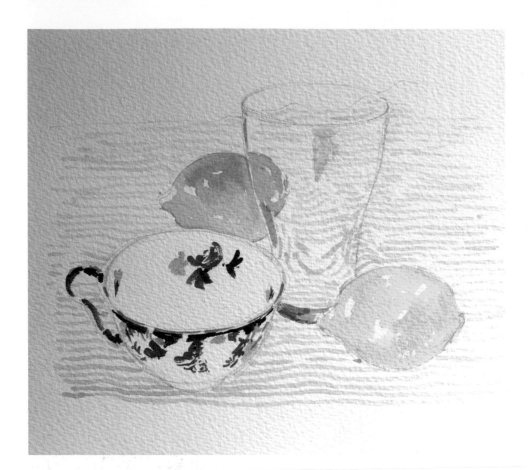

**More pattern is worked into the cup, and the stripes with their tonal recession and perspective are put in.**

Begin by putting in some of the pattern on the objects and the fabric. Get the colours right, testing them on a spare piece of paper before applying them. You do not need to copy the pattern in a completely accurate fashion. An approximation, in other words your interpretation of what you are looking at, is enough or even better but do make sure that the pattern follows the form of the object it is on. So if painting a pattern on a cup it will need to follow the curve of the cup, and the pattern will appear closer together as it goes around the side because of perspective.

When the pattern is complete go on to the organic objects remembering what you have learnt from the lemon exercises. Follow this by putting the shadow inside the cup, being careful to keep that important narrow strip of light that indicates the rim. Continue with shadow on the outside of the cup and do not be concerned if the pattern, which you have already painted, runs slightly. A little movement in the paint can look very attractive and is also characteristic of watercolour and how it behaves. However, if the pattern runs so much that it is no longer recognizable or you do not like the effect, then there is a simple remedy: leave the whole area to dry having made sure that the shadow is as you want it, but adjusting it if is not quite right. Picking up a slightly darker shade of the pattern colour, repaint just those areas that are at the front of the cup. This will

have the dual effect of making the pattern more precise again, as well as bringing it forwards and giving you the softer, more blurred part, which will help the side of the cup to recede.

Stop now and leave your work for ten minutes or more before coming back to take a clearer look at what you have achieved. Having painted in all the things that you have put together for the composition now is the time to decide whether or not you need a background. If in any doubt then it is probably best to leave it blank. If you cannot decide, then take a scrap piece of paper, big enough to cover a good proportion of the background, and paint it with the colour or colours that you think would enhance the painting. Remember that the background should be just that, background, so you don't want it to dominate the rest of the painting. Don't rush into a decision; it is better to leave your work incomplete for a week than spoil it in a moment.

There are two main methods of putting in a background wash. One is to lay in a flat wash which covers all of the background and the other is a broken wash, which leaves areas of white paper. The second method is the most appropriate for still life as it can suggest other things that may be happening in the background and is lively without being too intrusive. The next decision to make is which colour or colours to use. It is most important that the right colours are chosen and a good

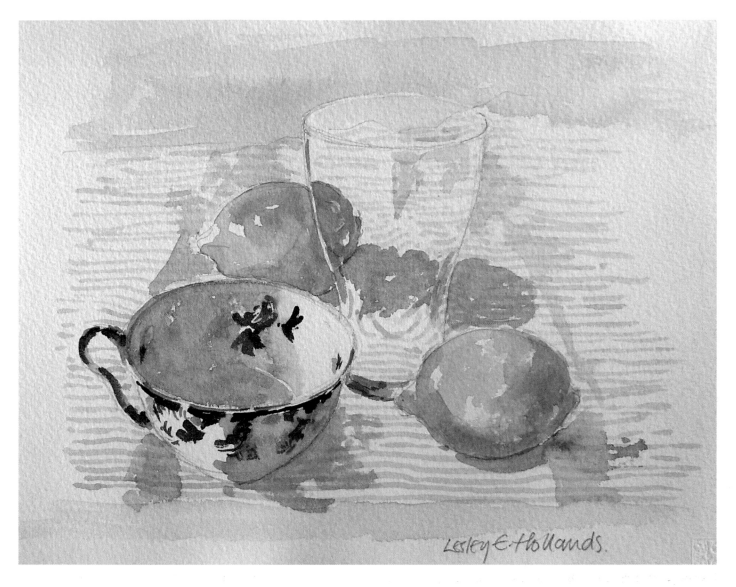

**The completed painting – it has taken very little paint to indicate the glass, thus keeping the impression of transparency.**

rule of thumb is not to introduce new colours at this stage but to use colours that are already a part of the composition. This ensures that the background stays a part of the whole composition and is unified with it. Try out any of the colours that you feel might work on a spare piece of paper and hold them up against the painting to help you make the right decision. Mix up a good quantity of the chosen colours and then, with your work lying flat, take a clean wet brush and wet the background where you want the paint to go. Drag the wet brush so that areas of the paper stay dry and then drop in your colour. The paint will only go where you have wetted the paper so you have full control over where it is going. Keep a paper towel handy for any accidents that may happen but you probably will not need it. Make the colour slightly darker nearer to the bottom of the background and lighten it as it goes up. This will help to give

the impression of depth and distance to your painting. If some of the edges of the objects furthest away run a little, especially the back edge of the fabric, let them because this will help those edges to recede and give the effect of tonal recession.

Look again at what you have achieved and try to assess which are the areas that have been most successful and which may need more work. Look at the painting as a whole and do not become too distracted by something that, to your mind, has gone wrong. Quite often mistakes are far less visible than you think and, if not pointed out to an observer, are just not noticed. Be positive and always try to see the good in the work you have done.

If you are too self-critical it may stop you working and it is only by persevering and continuing to practise that you will ever get any better.

Lesley E. Hollands

# FRUIT AND VEGETABLES

Fruit and vegetables are endlessly interesting to paint and come in such a wide range of colours, shapes and sizes that you need never use the same composition twice.

Individual fruits or vegetables, either whole or cut in half, can be a simple and relatively easy way to start. A lemon or other citrus fruit, cut in half across the middle to show the segments, is a very attractive subject for a still life and, if you are lucky enough to find one with some leaves attached, this makes it even better. Wrap the fruit in a square of white tissue paper, which you then pull open enough to show the contents, and this provides a small but challenging and interesting composition. Introduce some china to this group and you have further enhanced and expanded it. A bowl of soft fruits, strawberries, raspberries, gooseberries or any other berry can look delightful, especially if you choose a contrasting colour for the dish. The light, bright green of gooseberries looks lovely set against a dark green and white plate or bowl. Strawberries, with their green stems, look great in an arrangement with dark blue and white. Set these on a white cloth and you can capture the scent of summer.

So you see from just this brief description of a very few objects how much can be got from using fruits and vegetables in your still life.

## EXERCISE: ONIONS

For this project you really need home-grown onions with stalks still on. If you cannot get hold of home grown then go to a good supermarket and buy as many different types of onion as you can. Include the big Spanish onions with their golden colour, spring onions or scallions with their lovely bright green, red onions, shallots and any other sorts that you can find. Choose ones with a good colour, variety of size and as long a root and stem as possible. Arrange the onions in a row, overlapping the stalks and angling them in different directions. If you have no stalks then use the spring onions or scallions in the foreground of the composition to hold the group together. The group shown on page 46 has been placed on a simple white cloth with some crease lines where it has been folded and ironed, but a fabric with an uncomplicated pattern, such as a stripe, would also look attractive. Light the set up from a fairly low angle so the shadows add a further connection.

The paints that you will need include: Indian Yellow, Winsor Yellow, Burnt Umber, Raw Umber, Raw Sienna, Alizarin Crimson, Indigo and Sap Green plus a little Naples Yellow or Yellow Ochre and Titanium White. The paper used here is Fabriano Artistico 140lb/300gsm Rough, in a block.

Start by drawing your onions with care and attention to detail. Look for the subtle changes in shape and the way that the lines on the onions follow the form. Be aware of the different heights of the onions and the spaces between. The long stems are an interesting but challenging part of the composition so do not skimp on them; take your time to find the various twists, turns and angles that they make. The long stems in this composition went too far out to the right of the group but rather than physically cutting them short they were adjusted in the drawing to fit the design more comfortably. One of the good things about using onions as a subject is that they do not wilt or fade rapidly, leaving you plenty of time to complete the painting.

OPPOSITE PAGE:
**A column of chillies and stones.**

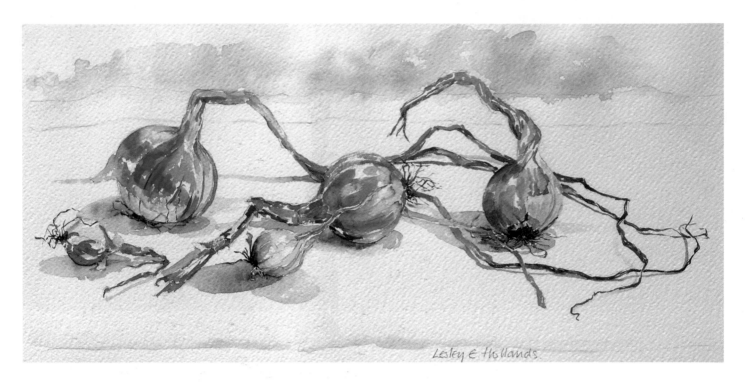

**The finished painting with an interesting range of shades in the shadows and a suggestion of background to give depth to the composition.**

small areas of colour are important as they are the darkest parts of the painting and are needed to give the contrast between them and the highlights on the glossy skins of the onions. If they are not dark enough some of the quiet drama of the painting will be lost.

The shadows are the next areas to be dealt with and alongside them the small pools of colour reflected onto the white cloth. The colour in the shadow is quite subtle and changes slightly with each onion. Colour is bounced off the shiny surface of the onions and reflected back from surrounding areas giving small but complex colour changes. Compare one area with another to try and see clearly the changes in tone and delicate colour variation. The shadow is deeper immediately underneath the onions and fades as it moves further away. The shadow is also softer at the back edge and crisper at the front. Using this variation can help to give a greater feeling of depth to the painting and also make the shadows lie flat.

Final touches are now put in. The dry, tangled roots of the onions make an interesting contrast to the smooth, firm, rounded surface of the rest of the vegetable. Where the roots are dark they can easily be painted in using a brush with a good fine point but there are some areas that are much lighter in colour and this is where an opaque pigment comes in useful. Yellow Ochre mixed with a little Titanium White works well, as does Naples Yellow, but try out combinations from your own palette to find what is best for you.

The painting is now very nearly complete and in fact could be left at this stage. However, it was decided that the back edge of the cloth needed to be indicated and a suggestion of a background put in. This has been done by wetting the area where the background was wanted, and a mixture of colours that had already been used in the composition was dropped into the wetted surface. The paint was then dragged a little to create soft but interesting areas of colour. The front edge of the cloth was then indicated with a little shadow. It was useful that the cloth was not completely flat as this had added a subtle interest and scope for variety in the front shadow.

The final painting has an understated complexity, which works very well.

## EXERCISE: A CUP OF STRAWBERRIES

This composition makes a charming group and is perhaps slightly unusual as it is not often that you see a cup full of strawberries. The addition of the plate under the cup and the white lace cloth add an extra depth and contrast. The colours work very well, with the brilliance of the strawberries being set off by the dark colours in the cup and plate. A delicate touch is added with the hint of lace on the cloth.

The paper used is Bockingford 140lb/300gsm Rough, from

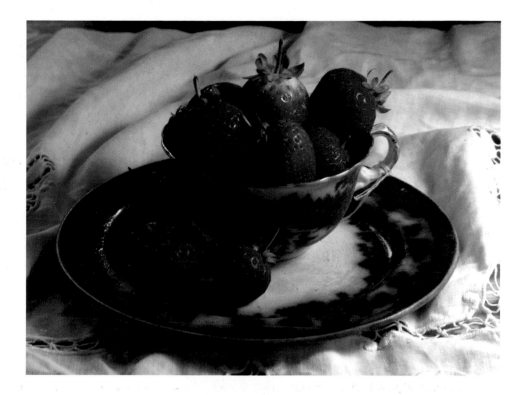

An appetizing cup filled with fresh strawberries.

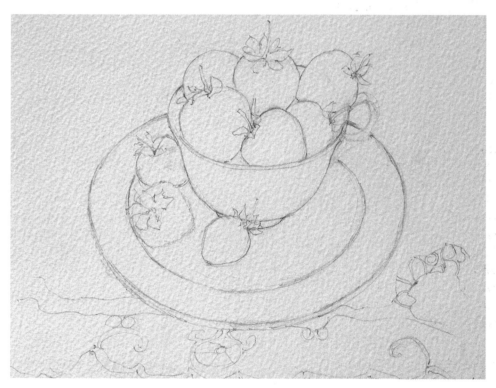

The composition is drawn out with just a suggestion of the lace on the cloth.

a sheet and the colours needed include: Winsor Red, Carmine, French Ultramarine, Indigo, Indian Yellow, Winsor Yellow and Sap Green.

The composition is first drawn out carefully, making sure that the ellipse of the cup rim and base are right and the shape of the plate follows through behind the cup and has the correct curve. Turn your drawing upside down or look at it in a mirror to help you see whether you have it right or not. Draw in the strawberries as though you can see the whole of the fruit. Do this quite lightly so that rubbing out unwanted lines does not

become a problem. By putting in the whole shape of the strawberries you are more likely to get them looking as though they are tucked right into the cup and resting on each other rather than floating on the surface.

Draw the strawberries on the plate making the one furthest away slightly smaller so that it sits back in the composition. If you do not feel confident enough to paint it freely, you could also draw in some of the pattern on the cup and plate, but it will look better if there is very little or no drawing on these areas. If you draw out too much of the design on the china it can end up being a little bit like painting by numbers and the result is rather stiff. The one aspect of the pattern on the cup that does need to be just right is the way the design follows the curve of the surface. If you look hard you will see that the pattern appears to squash up slightly on either side because of the effect of perspective.

The rim of the plate is another important part and needs to be drawn with care. The front of the rim is foreshortened so it appears narrower than the sides, which you are looking straight at. Put in the thickness of the rim as you do not want to lose this, observing how the rim appears wider at the front and narrows as it moves away from you on either side.

You are now ready to do a final check of the drawing, rub out any unwanted lines and prepare to paint.

Start with the strawberries as these are the lightest and brightest areas of colour and you do not want to lose any of

their luscious juiciness by muddying the colour. Use Winsor Red with some Winsor Yellow to lighten it where necessary and apply a dragged layer of paint with not-too-wet a brush. If in doubt as to how much water you need, try out a few brush strokes on the edge of your sheet first. By dragging the paint you will get flecks of white paper left showing, which give you the sparkling shine on the fruit. Leave too much white rather than too little as you can always reduce it later on, and although you can add in highlights with Titanium White at the end it does look better if you can leave white paper showing. Look for the range of colour in the fruit – it is often more of an orangey red nearer the stalk and deeper in colour further down. The variety of strawberry and the degree of ripeness also make a difference.

When the red of the fruit is complete, lay in some of the dark colour on the edge of the plate so that you are placing the darkest colour against the brightest colour. By doing this you can gauge whether your reds are brilliant enough and your blues dark enough. It is important to get the contrast of these colours right because if they are dulled down some of the brilliance and drama of the composition will be lost. The blue shade was achieved by adding a little Carmine to French Ultramarine. The colour on the plate varies slightly and the pattern is not very distinct, so it is pretty straightforward to suggest the design by drawing loosely with your brush and adjusting the colour by using more or less pigment. Be careful

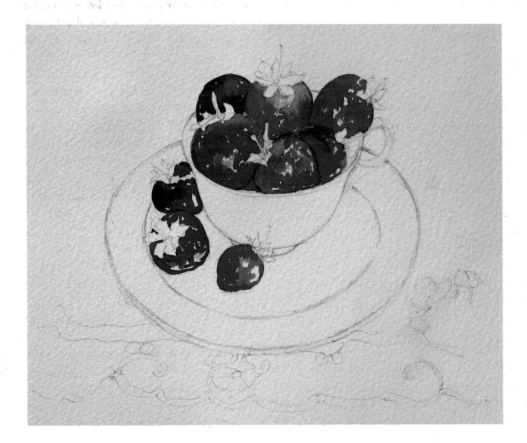

**The vibrant colour of the strawberries, leaving spaces for the leaves and highlights of white.**

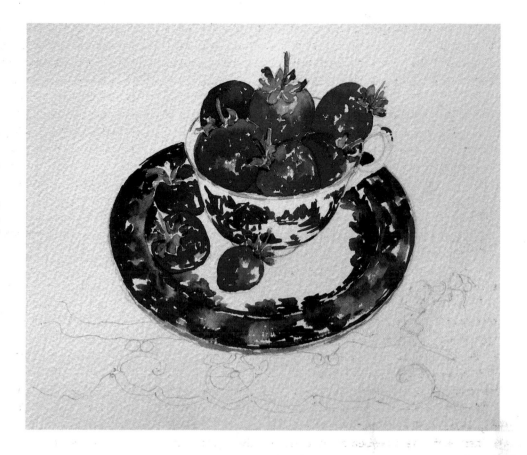

**The plate and cup are put in, making sure that the colour is strong enough to make the strawberries glow in contrast.**

to leave the white highlights where the shiny surface of the plate is catching the light.

When the basic colour on the plate is complete go back to the fruit and put in the stems and leaves. Use Sap Green as a base colour and make it lighter or darker by adding Winsor Yellow or Ultramarine Blue.

The pattern on the cup is the next area to be dealt with. It is a slightly different blue from the plate and needs more Ultramarine and less Carmine. Paint in the pattern using a brush with a fine point and make sure that the design follows the form or shape of the cup. You want to make the pattern look as though it is going around the cup and with the perspective at the sides the design should look denser and less detailed.

Stop and look now at what you have achieved, check that the drawing is still right and that the colours are working against each other to give the lively effect and contrast that you are aiming for. Make any adjustments that are needed before going on to the lace tablecloth and the shadows.

To get the effect of the lace you are going to paint the shadows in the spaces left in the lace pattern. If you have not done so already it is worth spending a little time drawing out the design of the lace fabric so that you do not over paint and make the delicate material look too heavy. It is also useful to have the holes showing a sympathetic colour. The lace here is on a pine table so the colour is quite soft and not too dominant.

If yours is on something that looks too dark then just slip a piece of white paper underneath it. By doing this you will get more blue tones in the shadows, which will blend well with the rest of the colours in the composition.

Do not fill in the shapes with a solid colour as this will make the material look more as though it is a spotted fabric than a lacy one. Where the material is lifted off the table surface slightly there is a shadow cast and this is what you are going to paint. Vary the colour slightly as you go, ranging the shades from a soft blue to pale yellow ochre. Where the shadow is next to the material the edge will be quite crisp and where it is away from the edge it will be soft. These are relatively small areas to paint but they are important as they give a delicate contrast to the stronger colours in the rest of the composition.

When the lace is complete the next areas to work on are the shadows. The shadows are going to make the cup look as though it is round and sitting on the plate, the strawberries as though they are piled on top of each other and tucked into the cup; they will indicate the dip in the plate and make the plate look as though it is sitting firmly on the cloth and make the cloth look delicate and raised slightly at the front. To sum up, the shadows are going to be working very hard and contributing a great deal to the painting.

Start with the strawberries and mix a deeper shade of strawberry colour by putting together Winsor Red, Carmine and a

**51**

little French Ultramarine. The strawberries on the plate are in a deeper pool of shadow than those in the cup, especially the one furthest back. Put the shadow on these first, being careful to keep the highlights and flecks of white paper showing. If it starts to look too heavy blot it with some kitchen paper before it has had a chance to dry. Go on to the fruit in the cup and again be careful to keep the shine. The shadow between the fruits and on the inside of the cup is quite dark so use this to give extra definition to edges where needed, for instance by the rim of the cup. Move on to the shadow on the cup and plate next. You may find that the wash of shadow will dissolve the pattern that you have already painted, but do not worry about this as the design can be sharpened up later if necessary. Keep the edge of

the shadow on the curved surface of the cup very soft so that it indicates that the cup is round and put in the reflected red from the strawberries. There is a little shadow on the right hand side of the plate, which shows the dip by the rim, which is useful to have. Be careful here to keep those very narrow strips of highlight, which show the curve of the plate.

The shadow cast by the cup and the strawberries comes next and if you look carefully you will see that there is a little light shining on the back of the plate on the right hand side. If you lose this small area of light you will make the base of the cup look as though it is very wide, which you do not want to do. The strawberries have quite a lot of red in the shadows from their reflected colour, which gives a pleasing extra lift to this

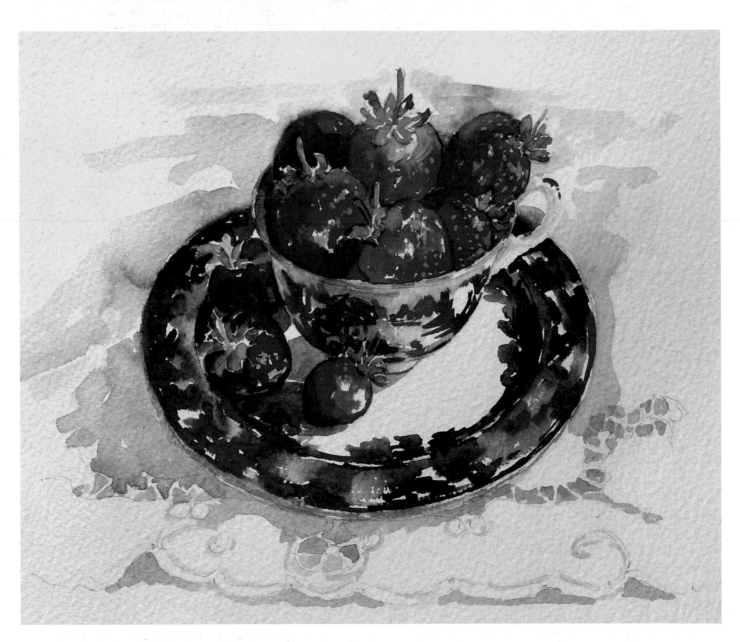

**The completed painting, with the back edge softened slightly to help it recede.**

area. The shadow at the base of the cup is darker and crisper, which helps show clearly that the bottom edge of the cup is sitting firmly on the plate. The shadow softens and fades as it gets further away.

The final part is the shadow on the cloth. This has picked up some reflected colour from both the china and the strawberries, which has created a soft mauve shade. When putting in the shadow around the plate be very careful to keep the highlight on the rim. If this gets lost then it will need to be replaced with some Titanium White when everything is completely dry. This shadow is also indicating that the cloth is not completely flat as it is following the soft undulations of the folds. The shadow cast by the raised edge of the cloth at the front gives a footnote to the composition and a full stop. Lastly, put a little shadow behind the group to push the background away, again using a mixture of the blues and reds that have appeared in other shadows.

Step back from your work and decide if anything needs pulling together or sharpening up, and make your final adjustments.

This is a charming composition, which includes delicacy with strength of colour and a slightly unusual arrangement.

## EXERCISE: CHILLIES

Chillies can be great fun to paint, especially if you can find some that are at various stages of ripeness and have a range of colours in them. There are lots of different ways of arranging them: try placing the small ones in a circle with all but one of the stems pointing inwards plus perhaps something unexpected such as a red bead or a snail shell as part of the ring; try piling the chillies up on a plate in an exuberant heap of brilliant colour; or you can create a simple row on a checked cloth or, as in this demonstration, string them together and hang them in front of a simple backdrop.

For this project the chillies were strung together by using a needle and thick thread stitched through the stalks. They were laid out roughly before they were joined up so that there was some idea of how the various shapes and colours would work together. A light-coloured fine twine was used, with the first chilli being tied onto the string to prevent it sliding off. A length was left hanging in case the string of chillies needed to be looped into a circle for better effect and the rest of the chillies were then threaded on one by one. If they seem to have a tendency to slip out of place then run the twine in a loop round each stalk and put the needle through twice. When all the chillies are in place attach them to a board that has some white paper or cloth covering it. Either tape them to the back with masking tape or, if you are using a thick board, hammer a nail

in and loop the string around that. Light it from the side to get some interesting shadows and you are ready to start.

Draw the group out carefully. The chillies often have interesting bumps and lumps and curious twists and turns to them,

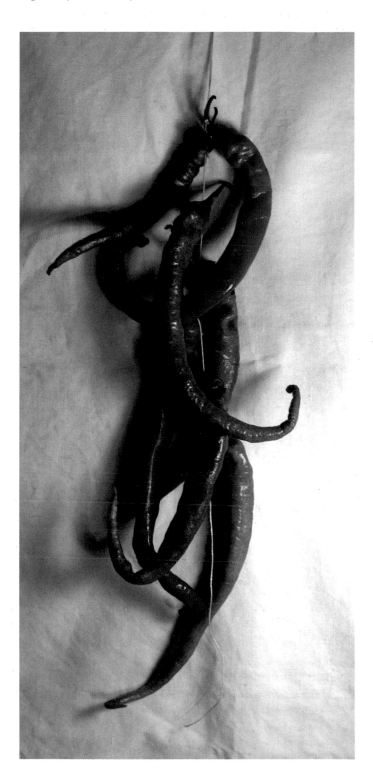

**A string of chillies attached to a board covered with a white cloth.**

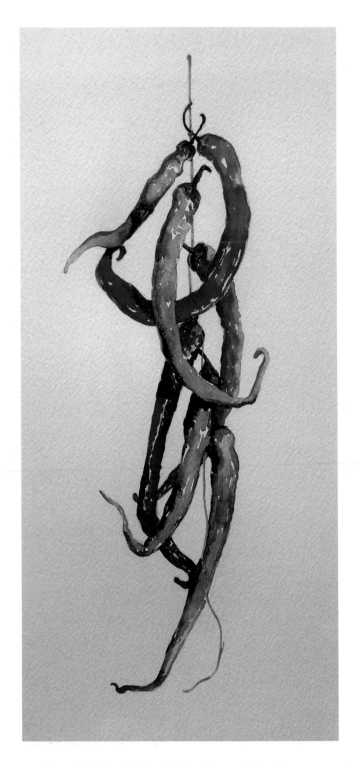

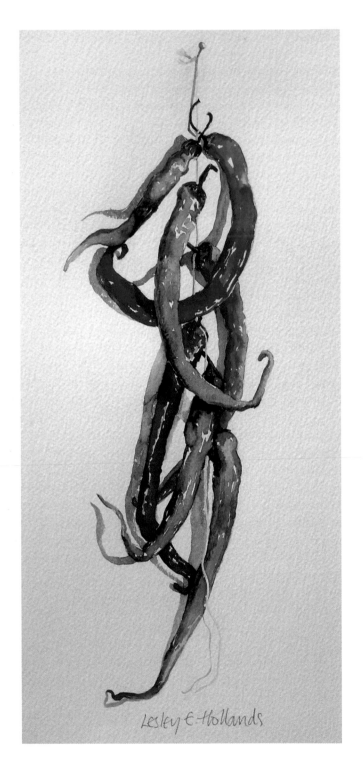

**More detail is added with the stems and shadows on the chillies.**

**The masking fluid is removed and the string and cast shadows put in with the finishing touch of the nail.**

and then mauve where the red chillies have reflected colour onto the white background.

The final touch is to put in a nail for the string of chillies to be hanging from. Even though this was not in the original set-up it was decided that a nail would finish the composition off nicely.

The final painting is, if anything, more interesting than the group itself appeared when first put together. There is movement and a greater degree of subtlety in the colours than was immediately obvious in the original, which just shows that sometimes art can improve on nature!

# EXERCISE: A BULB OF GARLIC

This subject makes an interesting, small still-life group. The colours can be quite difficult because many of them are rather pale with very subtle variations but the challenge is worthwhile. The best garlic to paint is the early, fresh bulbs, which have much more colour and usually the long stem still attached. There are pink and purple varieties as well as the more ordinary white sort. Break open the bulb and release one or two of the cloves, arranging them to form a group with enough space between the cloves to show the base of the main bulb. This will simplify the arrangement and make both drawing and painting it slightly more straightforward.

Fabriano Artistico 140lb/330gsm was used for this piece of work and the following colours: Carmine, Permanent Rose, Naples Yellow, Raw Sienna, Winsor Violet, French Ultramarine and Cobalt Blue.

The cloves were drawn with care, paying particular attention to the lovely, curling tips of the broken-away sections. It is important to get the tonal values right across the painting,

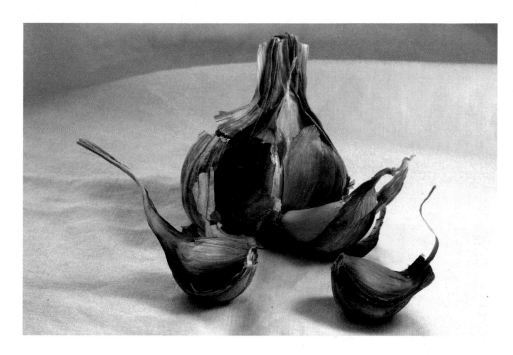

**A bulb of garlic split open to show the individual cloves and lit to give shadows that are not over long.**

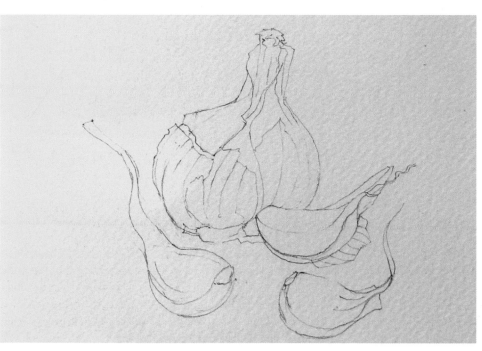

**The garlic is drawn out showing the interesting curves of the individual cloves.**

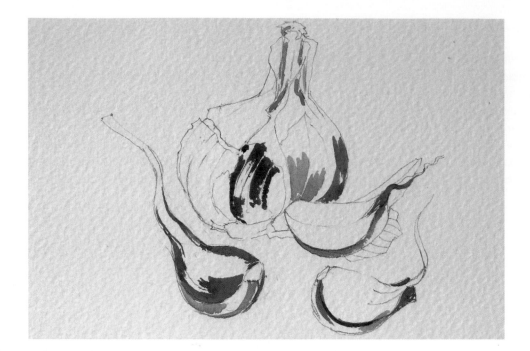

**Some of the deeper tones are laid in, along with areas of brighter colour.**

**More colour is put in across the group.**

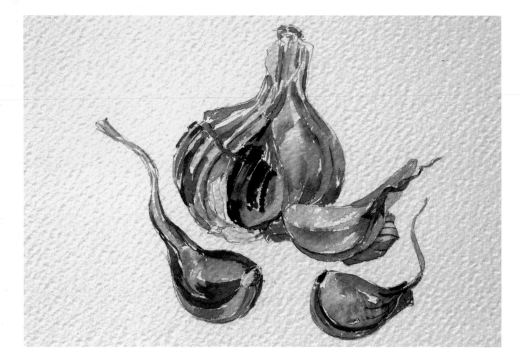

so to aid this an area of colour has been put on each section to start off. These areas act as a keynote and other tones can be adjusted in relation to them. Usually with watercolour you would work from light to dark because it is far easier to go over a light colour than a dark one. Here, because you are working on a relatively small area, and will not be building up the image with layers of paint, the dark colours have been put in early. You can then judge the level of tone for the lighter areas more easily.

There are some quite bright colours on the garlic, even though this is not one of the early varieties and it will help to give the composition more vibrancy if you do not lose these stronger shades. Permanent Rose and Raw Sienna have been used to get the orange tone on the right-hand side of the bulb. The mauve colour has been achieved by mixing Winsor Violet with Carmine and a little Cobalt Blue.

The papery skin of the garlic has pulled away from the main body on the left hand side. The delicacy of this area can be

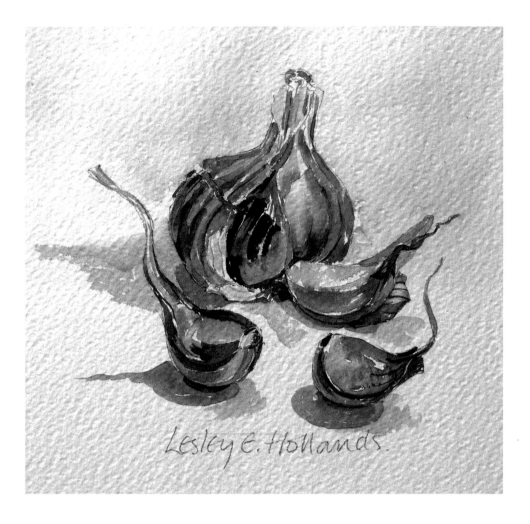

**The finishing touch is the shadow, both on the garlic and cast by it, making use of the subtle range of colours seen there.**

achieved by keeping the broken edges quite crisp and sharp and using the fine dark lines that are following the shape of the garlic. Do not overwork this area; just a hint of colour is better than too much.

The clove that has lost some of its skin and is showing its peeled colour needs a warmer, creamy colour. This shade has been made by mixing Naples Yellow with Raw Sienna and where there is a delicate shadow on the side some Cobalt Blue has been added to the mix.

Continue building up the composition, all the time looking for the subtly-changing colours in each small section. When the garlic is pretty much finished add the shadows. These have two areas: a darker section near to the garlic and a softer part that fades as the shadow moves away from the object. There is also a little warm ochre colour reflected onto the white cloth, which gently takes the harshness away and brings the colour from the garlic into the foreground.

The final touch is to run a little blue shadow over the sides of the garlic that are away from the light source. This will give them a greater appearance of being three-dimensional.

This is a small but charming study, simple yet effective.

## EXERCISE: CUPS AND APPLES

This is an interesting composition with the five apples arranged roughly in a circle around the three cups, and with everything placed on a simple cloth with a striped edge. The curves of the cups echo the curves of the apples, and the stripes on the cloth help to hold the group together in addition to making a contrast with the straighter lines. The colours are carried through the group with small amounts of green, yellow and blue in the pattern on the cups, linking the colours in the apples and the cloth.

Fabriano Artistico 140lb/330gsm Rough was used for this painting with the following colours: Winsor Yellow, Indian Yellow, Naples Yellow, Permanent Carmine, Winsor Red, Cobalt Blue and French Ultramarine Blue.

The group was drawn first, looking in particular at the uneven shapes of the apples. They are not smoothly round but have slightly flattened parts, which make them more interesting. Because they are home grown and rather misshapen they have a tendency to lean a bit and stems and ends are not quite central. Each of them are also very different in size. Putting one cup

**59**

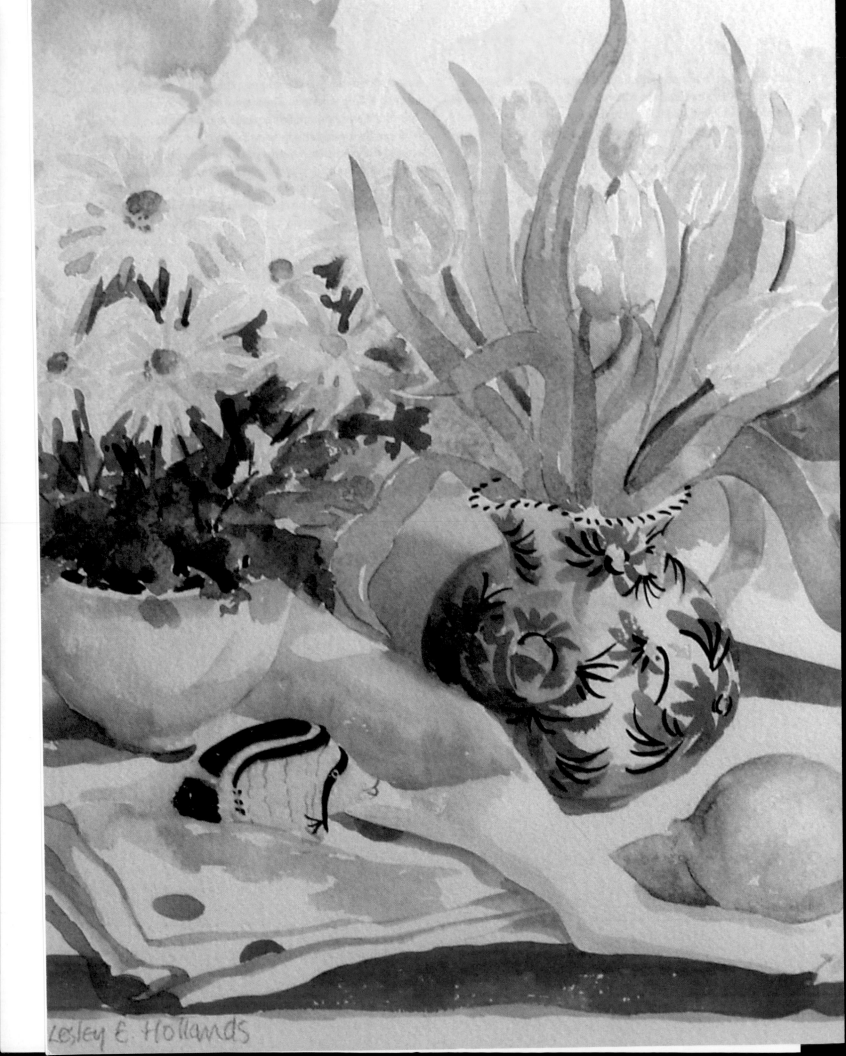

Lesley E. Hollands

# FLOWERS

Flowers make an excellent subject for still life, either on their own or as part of a group. There are many ways and styles of painting that suit flowers, spanning from the big, bold paintings of a single flower by Georgia O'Keefe through the carefully arranged works of Elizabeth Blackadder to the colourful, loose work of Paul Riley, and of course every stage in between and many, many other artists.

In this chapter we are going to look at a number of different approaches to painting flowers both in the style of applying the paint and the putting together of a composition. Flower paintings can look pretty but a little bland, so to make your work more interesting and original try thinking of different ways of presenting them. For instance you could put together a group of similar flowering plants, all in pots in a row. They could be placed in front of a window, which could be used for the background or against a patterned wallpaper or even against a simple white background with cast shadows giving extra interest. Further variation could be added by placing small objects between the pots: a striped snail shell, a coloured bead or an interesting pebble perhaps. Lighting the group from a low angle creates good connecting shadows or you could work *contra jour,* against the light, which would give quite a different feel to the painting.

A single orchid starkly painted, but with something in the foreground to add colour and weight, would make a stunning composition. White flowers against a white background sets a challenge but they look fresh and delicate as does a white flower arrangement against a coloured or patterned background. Putting flowers into a more supporting role can also

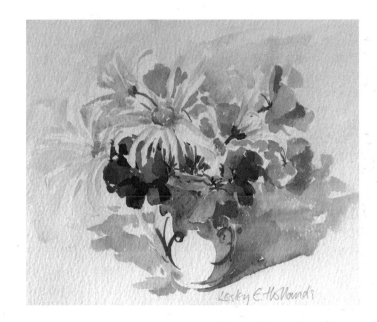

**Sweet peas and daisies.**

be a very effective way of using them. A straw hat with flowers tucked into the brim can look very pretty as can one or more small pots or jugs of flowers placed as part of a much larger still life group. In this situation the flowers can add colour and movement and lighten a composition.

A small posy of flowers tied with coloured ribbon can look pleasingly informal. A large armful of flowers, looking as though they have just been picked, would look great in a trug or even a bucket, where they could be exuberantly overflowing and very natural. This sort of arrangement would be ideal for a wet into wet approach.

**OPPOSITE PAGE:**
**Tulips and fish.**

The other extreme would be a very careful botanical study but this approach will not be covered in this book as it really needs a publication all of its own.

So as you can see, from this brief and by no means comprehensive description, there are many ways of using flowers in your painting without going for the vase of flowers in the middle of the composition against a draped cloth.

## EXERCISE: WHITE FLOWERS AGAINST A WHITE CLOTH

This composition makes a delightful painting, very fresh and delicate. It could be considered a challenge as you are painting white against white and the flowers are in a glass container but if you remember not to over paint there should not be any real difficulty.

The painting is on Saunders Waterford Not 300lb/600gsm which is a lovely heavy paper and was chosen so that it would not cockle when lots of water was used for the background wash. The watercolours used included: Sap Green, Hooker's Green Dark, Indian Yellow, Winsor Yellow, Raw Sienna, Ultramarine Blue, Cobalt Blue and Cerulean Blue.

The flowers and the vase were drawn out carefully to begin with. It is important to notice the different angles and spacing of the petals and the way that the flowers face in different directions. The glass is interesting because of the way it distorts what is inside it; also because of the refraction caused by the water, making the stems appear to be broken. The flowers are drawn in some detail so that very little paint is needed and they are not made to look too solid. Excessive pencil lines can be removed at a later time.

The first areas to paint are the centres of the flowers and the stems. The middles have a little green around the edges and the yellow varies from flower to flower. Sap Green and Winsor Yellow was used for the outer part of the centre and combinations of the two yellows for the rest. The paint is dragged slightly to give a textured appearance, as the centres are not smooth. The stems and leaves are different shades of green with the stems being lighter. The leaves are painted using a mixture of Hooker's Green Dark and French Ultramarine with a touch of Raw Sienna to soften the shade. The stems are Sap Green with a little Hooker's Green added for the shadow side. Leave a line of white paper to indicate where the water level is.

The background goes in next so that the white flowers are thrown forward. A good way to put colour into a small and complexly-shaped background, as it is here, is to use a controlled wet into wet technique. Take some clean water and a medium-sized brush with a good point and carefully wet the background. Take the water right up to the edges of the flowers but leave some small dry patches so that the background does

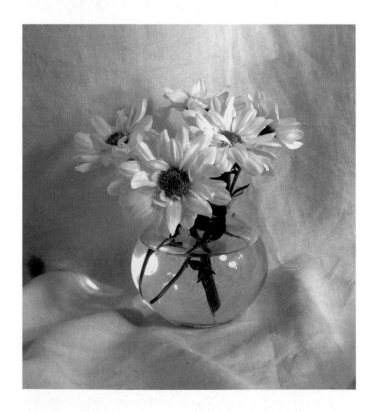

**White on white with clear glass – a challenging composition.**

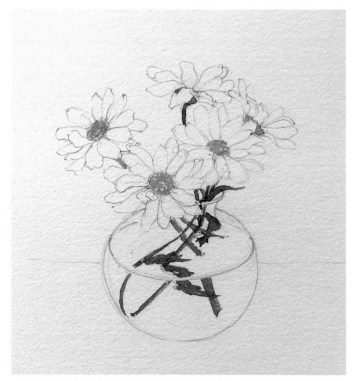

**The centres of the flowers and their stems are put in first.**

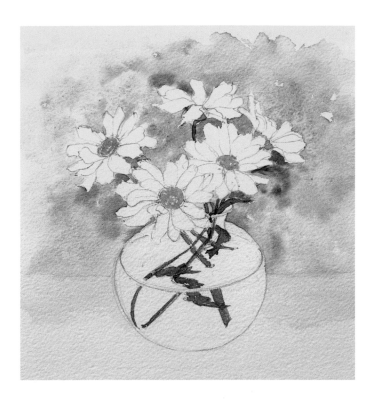

**The background shows up the shape of the flowers.**

not become too solid. Have a range of the three blues plus a little Sap Green mixed up ready to use and drop these into the wetted areas allowing the colours to flow into each other. The paint will only go where the paper is wet as long as you don't tip it up at a steep angle. You need to suggest that there is a foreground or surface that the vase of flowers is sitting on and a background going up behind the flowers but without being too precise. To do this, bring the background wash down to a line behind the vase and soften it by fading it out with a damp brush. By using blues and greens the background is kept light and fresh and very much in keeping with the feel of the painting.

The next stage is the flower petals and the glass and in both cases it is most important not to over paint. Look at how the shadows fall on the white petals and look for colour in the shadows. They possibly look grey and if you see them like this ask yourself what shade of grey. Is it a blue/grey or a green/grey or even a mauve/grey? If in doubt, then stick to shades of very pale green and blue. By doing this the flowers will stay looking fresh and clean whereas if you used a grey they would probably end up looking heavy and muddy. Put the minimum amount of paint on the petals. All you need to do is indicate where one petal is behind another by putting in the shadow cast with perhaps a little extra detail around the centres.

**Shadows pull the group together and soften the back edge of the flowers to add depth.**

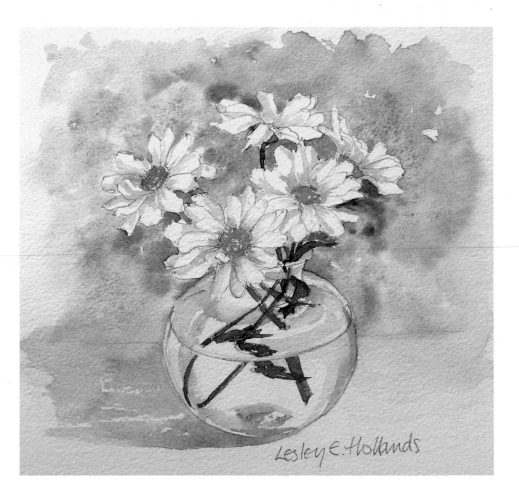

The glass is shown by painting what you see reflected on it and what you see through it, and again, be careful not to over paint. Do not be afraid to paint in the odd things that are caused by the distortion of the curve of the glass, they all add extra interest and variation. Keep to the same colours that you have used in the rest of the composition and make your brush strokes follow the shape of the vase. In this way you keep the unity of the painting and help the glass to look more three-dimensional. A mark to show the surface of the water is useful as is something to indicate the base of the vase.

When all else is complete put in the shadows cast, letting them run into the background. Stand back from your work and decide whether it needs any adjusting. Some of the petals that are facing away could be softened and allowed to merge into the background and petals near to you could be brought forwards by making the background a little darker nearer to them. Avoid outlining them, but if you do add extra colour, soften the edges with a damp brush leaving a darker area near to the petal and a merged area as you move further away.

The finished painting has a charming freshness and simplicity but with enough variation in colour and tone to make it interesting.

## EXERCISE: WHITE FLOWERS ON A PATTERNED CLOTH

This is a more complex group and is in some ways easier to paint because there is more in it to get to grips with. One of the interesting aspects of the composition is the way that the flowers and glass vase almost disappear against the cloth. A painting often becomes more interesting if you cannot see everything in it at first glance and need to go back for a second look, so do not be afraid not to spell everything out clearly in your painting.

The group was arranged on a low table so that you are looking down on the composition and the flowers are then seen against the background. The perspective of the cloth is an important aspect and needs to be got right in order for fabric to look as though it is lying flat and not going uphill behind the flowers. It was lit from a fairly high angle so that the shadows are short and contained within the composition.

Bockingford Rough 140lb/300gsm was used for this painting and the following watercolours: Raw Sienna, Carmine, Sap Green, Winsor Yellow, Cobalt Blue and French Ultramarine.

The composition was drawn out carefully first so that the flowers and the glass could be painted freely without being lost. The pattern on the cloth was put in with more detail at the front and a suggestion of the design further back. By fading out the design you help with the perspective by making the back look further away.

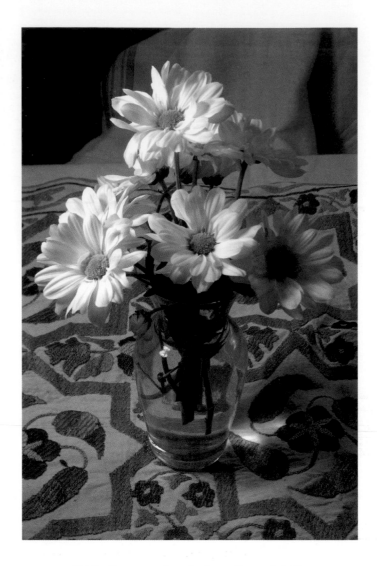

**White flowers set against a patterned cloth.**

## PERSPECTIVE – A BRIEF EXPLANATION

### Single Point Perspective

If you look down a railway line, even though you know that the parallel lines of the rails will never actually meet, they appear to do so at a distant point on the horizon. This is the basic principal of single point perspective. So if you are drawing a square or rectangular cloth lying on a table with objects on it these are the rules that you need to apply. The horizon line, which is where the parallel lines would appear to converge if they went that far, is always at your eye level. The point on the horizon line where they appear to meet is called the vanishing point. All parallel lines will meet somewhere on the horizon line/eye level.

Single-point perspective with tonal recession shown by the shading in the squares becoming lighter and less distinct as they go back in the drawing.

## Linear Perspective

Linear perspective is the way in which objects appear to get smaller as they get further away. Even in the small space of a still life set up on a table in front of you there will be linear perspective. To see this, lay out a cloth with a regular pattern of stripes or checks and put on top of this three objects of the same size placed one behind each other in such a way that you can see all three. Now take a pencil, hold it at arm's length, keeping your arm straight at all times (or you will change the measurement) and measure the height of the object nearest to you. To do this place the top of the pencil in line with the top of the object and then pull your thumb down to mark where the bottom of the object is. Keeping your thumb in the same position, compare this measurement with the other two objects; they should appear smaller. Do the same with the fabric. It is sometimes surprising just how much difference there is within the small space of a painting.

## Tonal Perspective

This is the way that colours appear to change and fade as they get further away. Detail is lost and colours generally appear slightly cooler. It is a good rule to remember that warmer colours come towards you and cooler colours recede.

The centre of the daisies and their stems are painted in first using Winsor Yellow mixed with Sap Green for the centres and Sap Green with French Ultramarine for the stems and leaves. Get some variety into the colours of all these areas and make use of the distortion that the glass makes.

Put in the fabric by painting in the pattern. Give yourself more guidelines if you need to, but a better, more fluid result is probably to be had by painting direct. Make the colours fade as they get further away and be particularly careful about going around the white flower petals. The colours used for the cloth are Carmine for the flower shapes, Cobalt Blue for the star shapes and wavy outer line and Raw Sienna for the background colour

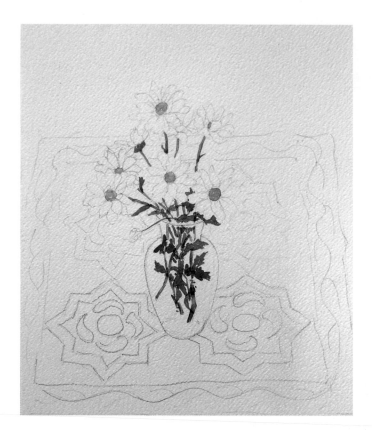

The vase, pattern and flowers have been drawn in and the flower centres painted in.

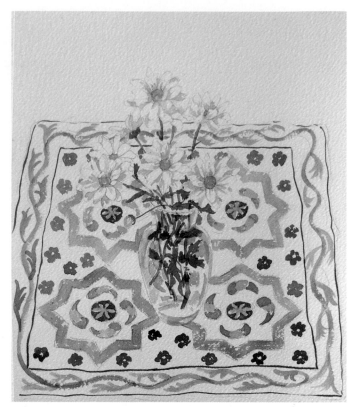

The cloth has been painted more distinctly in the foreground and some detail put into the flowers.

of the cloth. The soft orangey shade is achieved by mixing Carmine with Raw Sienna. Where the cloth is seen through the glass the shapes of the pattern are diffused and can be indicated by a few brush strokes of softer colour. Keep plenty of white paper showing through the glass to prevent it looking like a ceramic container.

Deal with the petals next, again keeping them as simple as possible to retain their delicacy and freshness. Use pale shades of blues and greens rather than greys.

Some of the flowers go above the back edge of the cloth so in order to delineate them a background is needed. A dragged wash of Cobalt Blue and Raw Sienna is put in, leaving broken areas of white paper showing. The background wash is taken down and over the back edge of the cloth to help it recede and connect it to the background.

The finished painting has a delicate richness of colour, with the simplicity of the white flowers and glass being attractively set of against the intricate pattern of the cloth.

The cloth has been painted and the background put in, which shows up the white flowers.

## EXERCISE: PINK LILIES AGAINST A DARK GROUND

This painting went through several stages before reaching completion. It is a dramatic composition, which needs a lot of courage to achieve a good result due to the amount of dark colour in the background. It is a large painting, A2 size, so careful planning was necessary to get the best out of it. The lilies were beautiful, fully open and just asking to be painted. There were some very dark-skinned Spartan apples nearby and these seemed to complement the flowers rather well and with the combination of the dark patterned fabric (that had once been a favourite skirt) a composition was born. The fabric was laid out on the floor and the lilies put into a simple glass container and the apples arranged around it. It looked wonderfully dramatic

when a light was shone on it from the top right. Even though the fabric was not big enough to become all of the background it was decided that it would look better if it was assumed to cover the whole area.

Fabriano Artistico Rough 140lb/300gsm was used on a glued pad to prevent excessive cockling with the following colours: Indigo, Carmine, Permanent Rose, Sap Green, Indian Yellow and Prussian Green.

The lilies were such wonderful shapes that it was an enjoyable task to draw them out carefully with all their curling edges and strong stems. They were drawn first because they were more important than the glass container and it would not matter too much if the vase had to be reduced in size, as long as it looked as though it could still hold the flowers. The apples were placed around the vase, making sure that the one at the back appeared

**A challenging and dramatic composition of lilies against a dark fabric with deep red apples.**

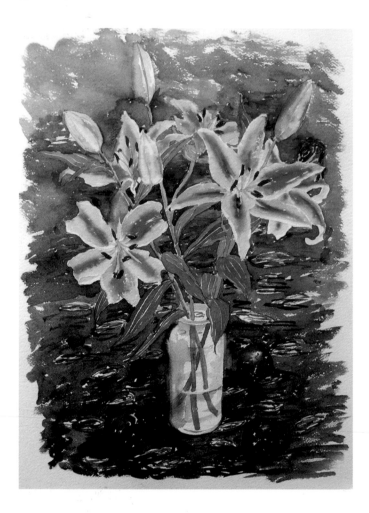

**Nearly finished but not quite there yet.**

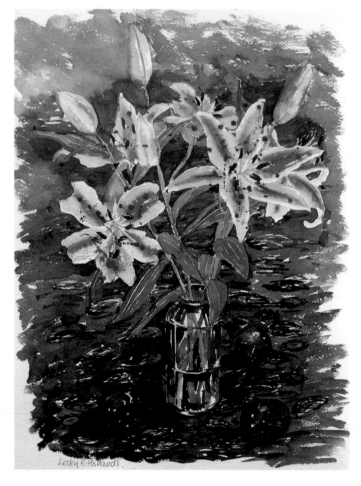

**The added darks and more colour behind the lilies have given this composition great strength and drama.**

# EXERCISE: ORCHID AND LEMONS

This is a deceptively simple composition made more interesting by using a high viewpoint and a circle of lemons. The high viewpoint is necessary because without it there would be a lot of empty space behind the flower stem, which would have the effect of dividing the painting in two. Looking down on the square pot improves it by making it look more three-dimensional as does being able to see the lemon tucked away at the back. Having the lemons placed in a circle takes your eye comfortably around the painting, framing the pot and leading your view up to the flower. The pot was placed on a white cloth with a lacy corner, which may or may not be included in the finished painting. It is better to have something like the cloth in at the start and leave the decision whether to use it or not until a later stage. If you were to put the cloth in later it would disturb all of the objects and possibly spoil the composition.

The paper used for the painting was Fabriano Artistico

Rough 140lb/300gsm with the following colours: Permanent Magenta, Indigo, French Ultramarine, Cobalt Blue, Sap Green, Olive Green, Indian Yellow and Winsor Yellow.

The group was drawn out first, paying particular attention to the angle and shape of the stem and making sure that the lemons appeared smaller as they went further back in the composition.

The flowers were painted using just Permanent Magenta in different strengths with the brush dragging the colour so as to leave flecks of white paper showing. If all of the white is lost, even in a small area like this, the flowers will lose some of their vibrancy and look rather dead. The dark stem goes in next using a mixture of Olive Green and Permanent Magenta to give a greenish brown. The stem is lighter on the right-hand side so more green is added to the colour to indicate this. An advantage of working from the top down on a painting like this, where the background is probably going to be left white, is that you are less likely to smudge your work.

The leaves act as an anchor to the base of the plant and

because they are so dark, give a good contrast to the white pot. They are not the most interesting shape so make sure that you don't lose the variety of colour and the curves, which make them more appealing to look at. Olive Green and Indigo were used for the darker areas with Winsor Yellow added for the lighter parts. Again, small areas of white paper were left showing in order to bring life and movement to the colour of the leaves. The supporting stick is painted in using the leaf colour but with Permanent Magenta added. The stick also has a thin line of light down the right hand side, which is indicated by running a damp brush down the edge to pull out and lighten the colour.

The lemons vary in colour, with some of them being rather under-ripe and having a distinctly green tinge. The two yellows were mixed together in varying amounts and a little Sap Green added for the less ripe fruit. A suggestion of shadow was then added with a mixture of Cobalt Blue and Sap Green.

The plant pot has some useful reflections from the lemons on the corners so this has been put in with a brush stroke of Winsor Yellow. Inside the pot the earth shows as a deep, rich brown, similar in colour to the stick. The surface of the soil is uneven so the paint is dragged and dotted on to achieve this effect. The inside of the pot is also quite dark with a blue shadow, which is put in with a mixture of French Ultramarine and Permanent Magenta. The outside of the pot has a broken shadow on it because of the shiny surface, so a lighter mixture for the interior shadow is dragged across. Some of the yellow on the corners needs to be kept, so that when the shadow is dragged across the edges are left clear and bright.

The shadows cast by the pot and the lemons are going to indicate the flat surface that they are all sitting on and give an indication of where in the picture plane the objects are. The lemons at the back have a lighter shadow, which shows that they are further back in the painting; conversely the lemons in the foreground and the front edge of the pot have a much darker shadow underneath them and a slightly darker shadow

**The plant is drawn in and the flowers painted first.**

**Leaves and stems are put in.**

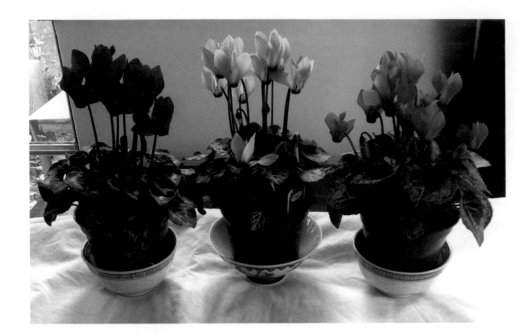

A row of cyclamens.

# EXERCISE: A ROW OF CYCLAMENS

This is a charming arrangement with three cyclamens of different shades that have been chosen to blend with each other and with the Chinese pots adding an extra element of pattern and colour. This is a good arrangement to do in the winter when flowers are not available from the garden and are expensive in the shops. The pots could have been arranged on a window ledge and the view outside included in the composition, or they could have been put on a patterned cloth or against a patterned background. It was decided here that the flowers had enough interest in themselves and, apart from the blue and white china bowls, nothing else was needed.

Bockingford 140lb/300gsm was used for this painting with the following watercolours: Permanent Magenta, Permanent Rose, Cobalt Blue, French Ultramarine, Cobalt Blue and Sap Green.

The brown plastic pots are not very interesting so they have been shortened slightly and hidden behind leaves. The pots and bowls were drawn out first but the flowers left out so that they could be painted in freely. The shapes of the petals really lend themselves to almost a single brush stroke for each one.

When choosing only to draw part of a composition like this it is important to make sure that you are leaving enough space to fit in the rest. It is very annoying and frustrating to paint in all of the pots and leaves only to find there is not enough room for the flowers. To avoid this situation indicate lightly with a few pencil marks where the tops of the flowers will go on your sheet of paper.

To make doubly sure that the flowers will fit in comfortably they are painted in first. The left-hand blooms are pure Permanent Magenta, the centre a dilute version of the same colour and the right-hand flowers are Permanent Rose. The petals are painted in individually with a single brush mark that is slightly dragged to keep the colour uneven. When the first shade is dry the little keynote of darker colour is put in at the base of each flower and then a second brush mark of deeper colour is put in to indicate shadow and movement. Be careful not to overwork the flowers and risk losing their delicate fragility.

The stems are put in next with a mixture of Olive Green and Permanent Magenta, varying the colour slightly from stem to stem. The leaves are painted in a similar way to the flowers but using a first layer of Olive Green and a second of Olive Green mixed with French Ultramarine. Make sure that the leaves look as though they are growing out on all sides and that the stems are coming up through the leaves in the centre. The leaves at the back should be lighter and less well-defined.

The china bowls are painted in next, using a combination of the two blues – the pattern being indicated with a few lines drawn in with a brush. Make sure that the pattern follows the shape of the bowl and does not flatten it by going straight across.

The plastic pots are dealt with next. They are not attractive objects in their own right so you will need to make them look better than they actually are. To do this, make the colour less red and more of a warm brown with Burnt Umber. Mix this with some French Ultramarine for the darker areas and leave the wash broken to suggest a bit of surface texture and you will have a far more interesting pot. Let some of the pot colour run on the shadow side so that it looks like the reflected colour on the inside of the bowl and then put a blue shadow into the inside on top of this colour.

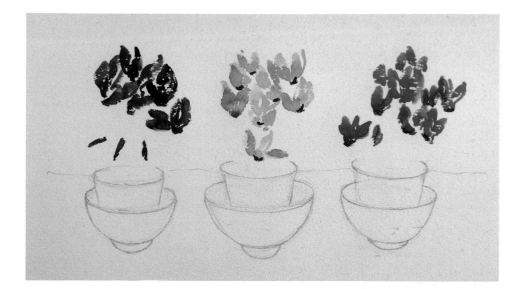

The group has been drawn and the flowers put in first, with some of the darker shades on each bloom.

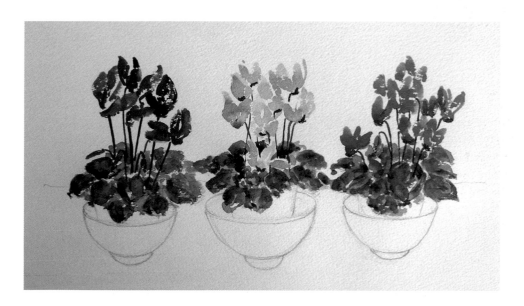

Leaves are added next.

The blue bowls and the brown pots are added with their shadows.

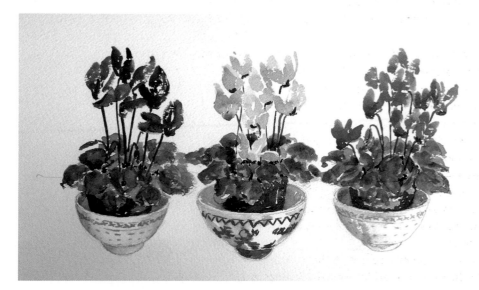

There are small areas of dark soil showing between the leaves and these are put in with more of the Burnt Umber and French Ultramarine mixture. These dark marks can help to separate out and redefine the leaves where needed.

The cast shadows from the bowls are interesting and varied in colour. There is a range of blues, greens and purples that should not be missed and a touch of darker colour right underneath each bowl that helps to anchor them to the surface they are standing on.

The painting could be considered finished at this stage and would be a very acceptable piece of work but a background would take it just that step further by suggesting that some-thing else was happening behind the flowers, thus giving added depth to the composition. Here a dragged and broken wash of Permanent Rose, Permanent Magenta and French Ultramarine, all very dilute, was applied to the background. Some of the flowers and leaves at the back of the composition were encouraged to run lightly, which improved still further the feeling of three dimensions.

The finished painting is a slightly unusual shape, which makes a pleasant change and looks most attractive with the blue and white bowls adding a crisp contrast to the softer and more loose painting of the plants.

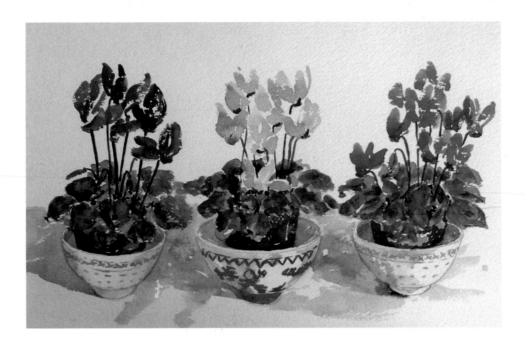

**Cast shadows are added, with enough variation to suggest folds in the cloth.**

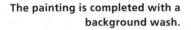

**The painting is completed with a background wash.**

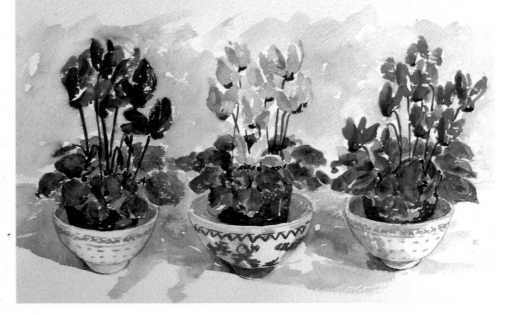

# EXERCISE: WHITE ORCHID

This white orchid is a beautiful, almost stately plant with a gorgeous array of closely packed blooms. It has been grown in a plain container but for this painting the pot and lower leaves are going to be left out and the whole composition will be about the flowers. The curving, dark coloured stems are important since they give contrast in both shape and colour to the arching forms of the white flowers, as does the supporting stick.

Fabriano Artistico Rough 140lb/300gsm was used for this painting with the following watercolours: Indigo, French Ultramarine, Winsor Red, Winsor Yellow and Olive Green.

The flowers were drawn out with care, as they are complex in shape and tightly packed together on the stem. In order to make better use of the line of the stem and the stick running through, the position of some of the flowers was changed. It

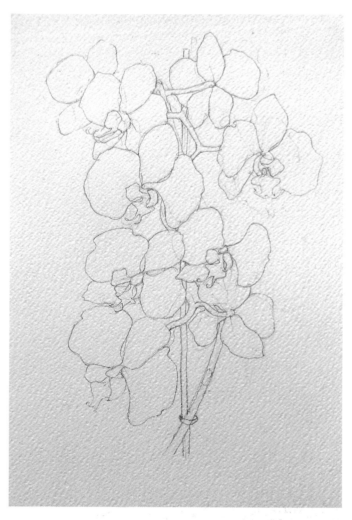

**The flowers are drawn out with care as it is quite a complex composition.**

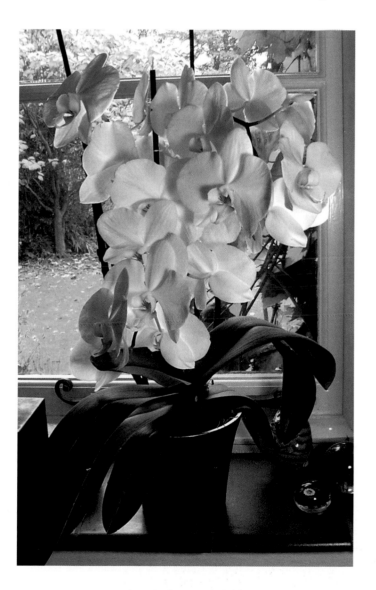

**The whole orchid plant.**

seemed a shame to pick any of the flowers so they were just drawn in different positions. This is a useful thing to remember; just because something is there in front of you there is no rule saying you must draw it in. In the end it is your painting and what goes into it is your choice.

The stems and supporting stick were put in first so the flowers could be made to work around them. The stick was almost black but this colour would have been too dominant so it was painted a warm Olive Green with a little blue added for the darker side. The stems are much lighter so Olive Green has been used for the shadow side and a little Winsor Yellow added for the light. The two colours are blended together by running a damp brush down the join.

The white flowers would be easy to over paint as there is a lot of shadow on them. To avoid this, pale, delicate shades of mauve and blue are used with just a suggestion of yellow on some areas. Paint is put on a small section at a time and the work

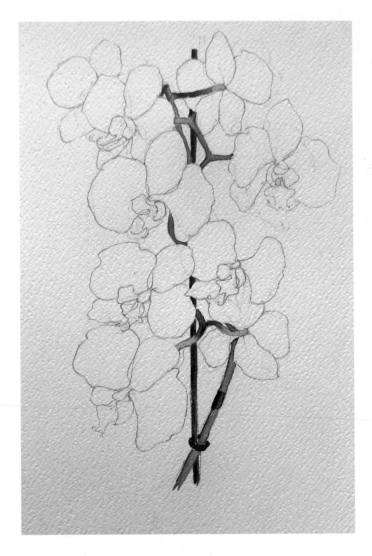

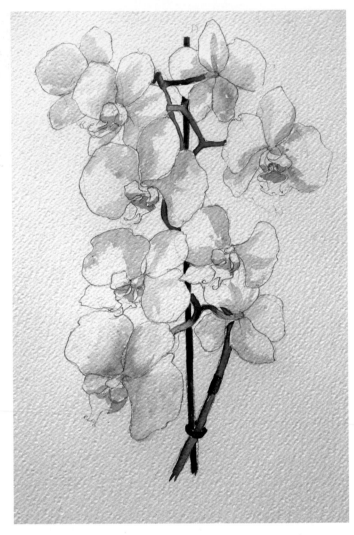

**Stems and stick are put in first, which helps to clarify where the flowers are.**

**Shadows are painted on the flowers, being careful to keep the colour looking delicate and fresh, and the yellow middles added.**

propped up at frequent intervals in order to judge the effect. As soon as a flower looks three dimensional, stop painting and go on to the next bit. It is always possible to go back and add more if it is needed but far more difficult to undo something that has been over painted. If you do find that some areas are looking too heavy you can use Titanium White to bring back the lighter parts but avoid putting too much on because it is a very opaque paint and tends to sit on the surface.

The background is going to be used to really make the flowers stand out without dominating them and to this end shades of blue have been chosen. By using blue, the shadow colours on the flowers are made more noticeable; also the colour suggests a summer's day, which seems to go rather well with the composition. Lay the painting flat and wet the background with a brush dipped in clean water so that the small spaces between the flowers can be easily dealt with. Indigo and

French Ultramarine are dropped into the wet areas, the colours being encouraged to merge together in places. Some of the flowers that are facing away have background colour pulled across them to make them recede.

The flowers now need their final adjustment where necessary and the touch of red in their centres, which really brings them to life.

The completed painting is very bold and powerful with the strong shapes of the flowers being enhanced by the deep blues in the background.

**OPPOSITE PAGE:**
**Background colour is added, creating drama and showing up the flowers, which have been softened at the back to add depth.**

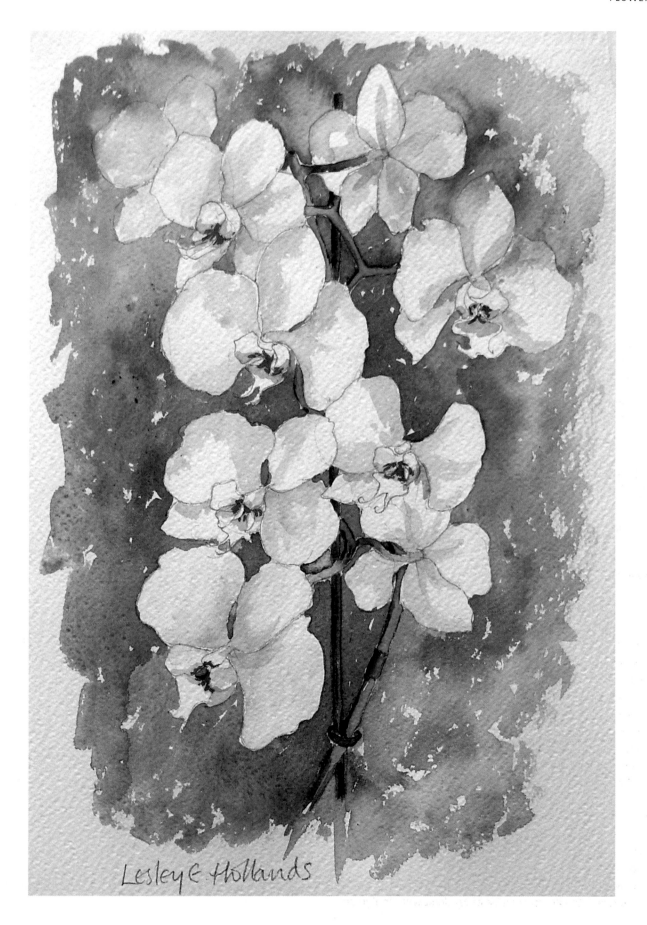

Lesley C Hollands

Lesley E. Hollands.

# LOOSEN UP WITHOUT LOSING CONTROL

Once you have been painting for a while and have become reasonably proficient you may find that your style has become rather over careful and tight. You might be quite happy with this precise way of working, in which case skip this chapter, or you may want to loosen up and gain greater fluidity with your painting, in which case read on.

There are various reasons why painting can become tight and some of them are as follows:

- You may worry about wasting the limited amount of time that you have for painting, so feel that by keeping everything under tight control you won't go wrong.
- You may be concerned about wasting paint and paper and feel that every painting has to be 'just right'.
- There may be pressure from friends and family to make everything look just as it is, so you try to make a more photographic interpretation rather than your own.
- You may be afraid to allow the viewer to interpret your work and feel that you must spell everything out just so.
- You may be painting on too small a piece of paper, which makes it difficult to use larger brush-strokes and flowing washes.

Any or all of these things can prevent you from letting your imagination and your paint flow, stifling your confidence and your ability to experiment.

The following are some exercises to help you change direction and relax into your painting once more and move forwards.

OPPOSITE PAGE:
**Yellow flowers in a blue jug.**

Take a sheet of paper, it could be the back of an unsuccessful painting or some scrap paper, just so long as it is intended for watercolours it does not matter what it is. Collect some of your larger brushes and include something really big such as a 4cm (1½in) house-painting brush. Have a large mixing palette ready – an old dinner plate works well – and put out two primary colours. Using each brush in turn take one colour and run lines of paint down the paper, varying the pressure on the brush as you go in order to create stripes of varying widths and colours. Drag the brush, using its side to leave uneven marks with speckles of white paper showing through. Wash out your brushes and, taking the second colour, do the same thing but this time run the lines horizontally across the stripes that you have already painted. Before the lines are completely dry, run a damp brush along one edge to make the line soften and run.

By doing this you are improving your brush control and finding out more of what the paint and brushes will do for you. When you feel relaxed and confident with the way you are handling your brushes go on to the next exercise.

## EXERCISE: SUNFLOWERS

Buy some sheets of the most inexpensive watercolour paper that you find. You could use the back of unsuccessful paintings if you have any. Find a really large brush; one that is used for house painting would be ideal.

Set up a bold still life with perhaps some sunflowers in a jug plus a couple of lemons, all on a simple cloth with some strong colour in it. Blue and yellow always look good together and have the added advantage of mixing to pleasing shades of

**The dark centres go in with more of the cloth, again working across the composition, and reflected colour put on the pot.**

**The painting is completed with more shadow in the background on the left.**

darker on the left-hand side where the vase is blocking the light shining from the left. There is also reflected yellow and green on the top of the vase. The fallen petals are put in next, and as one is on top of the cloth, Cadmium Yellow has been used to prevent the cloth colour showing through. One or two more petals are put into the sunflowers, again using the Cadmium Yellow in order to go over any background colour.

Finally, shadows are added. These are very important as they pull the whole composition together. A dark shadow has been placed to the right-hand side of the vase, allowing this edge to almost disappear into the background. The shadows on the blue cloth have gone over some of the leaves in order to push them back into the composition. The vase has had more yellow put on it, and this has been allowed to dry before the shadow has been applied. It is important that the shadow on the curved surface of the vase fades out and does not stop abruptly. If there is a hard edge to a shadow on a curved surface it won't appear to be round. The lemons have more shadow on them and a cast shadow area, which anchors them to the surface they are resting on.

Step back and look at your work, then leave it for a while before making any final adjustments. Do not overwork it. This type of loose and free painting is best viewed at a slight distance much as Impressionist paintings are.

## EXERCISE: MARIGOLDS AND CORNFLOWERS

Colours used are Carmine, Permanent Rose, Indian Yellow, Winsor Yellow and Sap Green and the paper is Bockingford Rough 140lb/300gsm. A Number 8 synthetic sable brush is used for the broader areas and a Number 6 brush for the rest.

This painting is worked on a rather smaller scale than the previous exercise and involves the use of masking fluid. Masking fluid is a latex solution which, when it is dry, resists any paint that goes across it. When the paint is dry, the fluid can be rolled off with your finger leaving clean white paper underneath (a very satisfying process). However, when using this painting aid

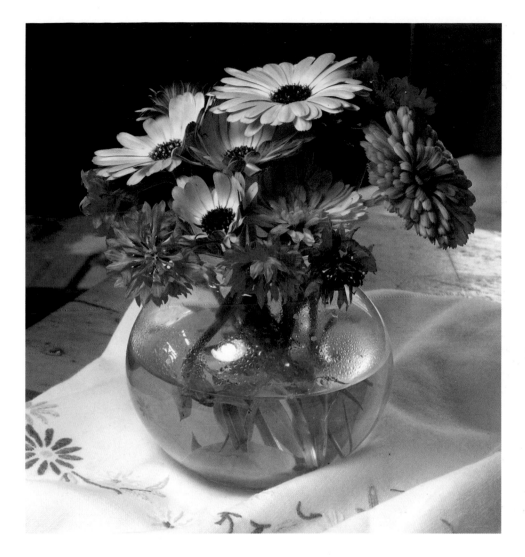

A charming composition of marigolds and cornflowers.

be careful to work back into the white area revealed or you will be left with a white space which stands out as an unnaturally stark and hard-edged part of the composition.

Masking fluid is useful here as the contrasting colours in the group would mix to a rather muddy shade if not kept separate. This would be singularly inappropriate for this piece of work as the cornflowers need to keep their freshness. The glass vase has been drawn in lightly so that it is not lost and the highlights saved with masking fluid. The cornflowers are a lovely, intense bluey-mauve and the areas where these flowers are to go have been masked out with Schmincke masking fluid. This product comes in a blue colour, which means it is much easier to see where you have put it. Do not apply the masking fluid with a brush because if it dries in the hairs it will never come out. Either use the nozzle that comes with some bottles of fluid, the wrong end of a paint brush, or even a sharpened stick. You could also use an old paint brush and wash it out after use with warm soapy water.

When the fluid is completely dry you can begin to lay in colour where the marigolds are. You can be quite exuberant here, letting the colour flow and splash in order to capture the brilliance of colour and their bold but simple shape. Try to get the colour strong enough so that a lot of extra layers are unnecessary and in this way the whole painting will stay fresh. Put in the stems, looking for the variation in their colour and use a fairly simple line to indicate where they are. Make use of the way the water refracts the light and makes the stems appear to change direction. Add a little colour to the glass vase; just enough to indicate some of the reflections of colour on the surface. By using the masking fluid to keep the highlights clean and white, you can be much freer with the way you apply the paint. Make sure that your brush marks follow the curve of the glass. Because you are aiming to put very little paint on the glass, so that it does not become too opaque looking, every brush mark must work hard for you.

The cloth has a little bit of embroidered pattern on it, which can be put in quite simply with a good pointed brush. The angle of the pattern has been altered slightly so that it goes

The glass is drawn out and masking fluid used for highlights and the cornflowers.

The marigolds are put in with simple, direct brush strokes.

**The glass is appearing now, as the stems and leaves are painted.**

around the bottom of the vase. Do not forget that you are in control of your painting at all times and can make any changes that you like, when you like. By moving the embroidery on the left so that it is nearer the vase, the eye is taken into the composition rather than being led out of it.

When all the paint is completely dry you can remove the masking fluid. To do this, roll it gently with a clean finger and it will magically reveal beautifully clean white paper underneath. A small word of warning here: do not leave the masking fluid on your painting for more than 48 hours and do not keep it for too long in the jar as it can then penetrate the surface of the paper and tear it as the fluid is removed. It should last quite happily for a year or more if kept in a fairly cool place.

Mix a good shade of mauve for the cornflowers. It should be quite a bluey-mauve, which can be difficult to mix. Here Winsor Violet has been mixed with French Ultramarine to get the right shade with some mixes tipping more towards the blue

and some more towards the mauve. Apply the colour using a brush with a good point to get the impression of the spikiness of the petals. A few splashes of mauve to go with any splashes of orange helps to take the colour across the composition. While this is drying, put the dark centres into the marigolds and then mix a darker mauve with a touch of red in it and put the centres of the cornflowers in. Decide whether the marigolds need any more variation of colour on their petals and put it in now if it does. Also look at the cloth and decide whether the embroidery needs a little of the orange put into it to bring the colour down into the foreground and anchor the composition.

Last of all put the shadow cast by the vase onto the cloth. Pick up the greens and blues from within the vase as you do this.

Prop it up and leave it. Go back to it later and decide whether it is completely finished or needs a touch more here and there. Too little is better than too much and remember, do not over work.

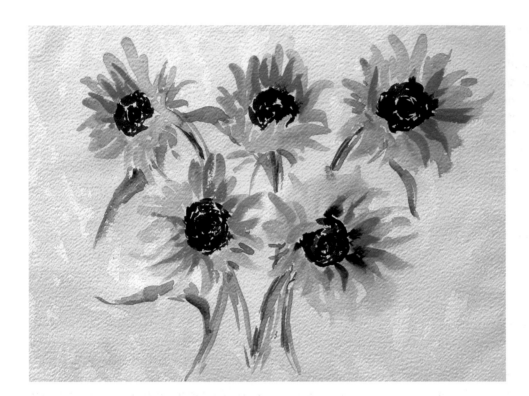

**Leaves are added, and more colour in the flowers .**

Drag the paint across the centre so that small flecks of white and yellow show through. This will help to keep that lovely sparkle that a good watercolour painting has. Vary the colour so that there are some lighter and some darker areas, the darkest part with these flowers is in the centre.

Go back to the petals and work into them, building up the colour where needed and adding more if appropriate. There will be a shadowy side and a lit side to most of the flower heads and you can achieve this by using different shades of yellow as well as by putting on a shadow wash. Making use of the light

**The painting is completed with some dark greens in the background, which throw the sunflowers forward.**

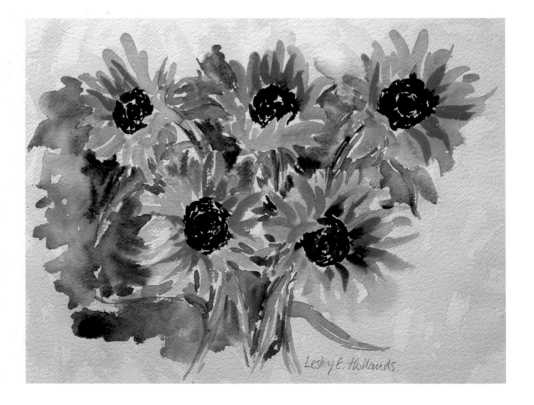

and shade makes the flowers look more three dimensional and dramatic on the page.

Finally, you need to look at the background and decide how to handle this. If you have enough colour left from the first wash then you may not need to put in anything else, but if the sunflowers are sinking into the background too much then something else is needed. Not all of the flowers need to be pushed forward, it looks better and more interesting if some areas dissolve and other areas are made to be more precise. The areas in shadow are generally the parts that need to disappear more and the ones sharply lit need to be brought into greater focus.

Do not rush into putting in the background. Prop your work up somewhere where you will catch a glimpse of it unexpectedly and wait until you are completely sure about what you want to do before putting in those finishing touches.

With this painting the sunflowers, although bright and cheerful, lacked some degree of drama so it was decided that a background would be an appropriate addition. The background needed to be controlled so that it did not over-dominate the flowers. The aim was to make the flowers more dramatic by putting some stronger colour in behind them; at the same time it was important not to lose the shapes of the petals. In order to achieve this, the area where the background was to go was carefully wetted with clean water and the paint dropped into these areas and allowed to move of its own accord. A little manipulation with the brush was needed to pull the colour down between the petals and soften any hard edges that were appearing where they were not wanted, also to lighten the shadows on the right-hand side, nearer to the light source.

The finished painting has colour, drama and a great freedom of approach.

## EXERCISE: CUPS AND STONES

This project is more difficult to do as the objects in it do not lend themselves so readily to a freer approach. However, a very attractive painting can be produced using an uninhibited, direct method of working.

An arrangement has been made of cups with patterns on them, placed roughly in a circle, interspersed with stones that have interesting markings on them. The addition of a red bead tucked into one of the cups, a satsuma in another and a dark plum in a third adds unexpected splashes of contrasting colour. A plain white cloth, which has been folded, is used underneath with the creases creating useful horizontal and vertical lines. These lines can help to position objects correctly and also give some softly straight lines to contrast with all the curved hard edges of the other parts of the composition.

Take a sheet of paper, A3 minimum size, Fabriano Artistico Not 140lb/300gsm was used here with the following colours: French Ultramarine, Cobalt Blue, Indigo, Permanent Rose, Carmine, Indian Yellow, Yellow Ochre and Raw Sienna. Light the group so that useful shadows are created in the cups and on the fabric. It is best to stand for this particular composition as it allows for greater freedom of wrist and arm movement, so arrange the lighting while you are standing in the position that you will be working. If you feel particularly nervous about

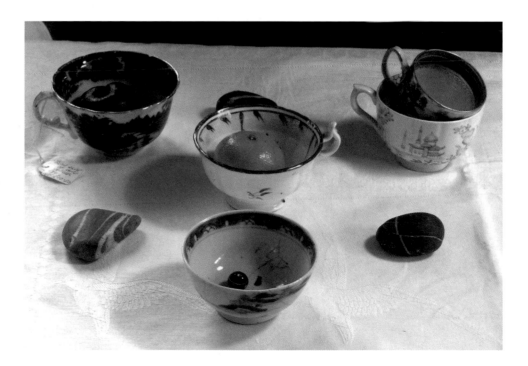

**A circle of cups and stones make an unusual composition.**

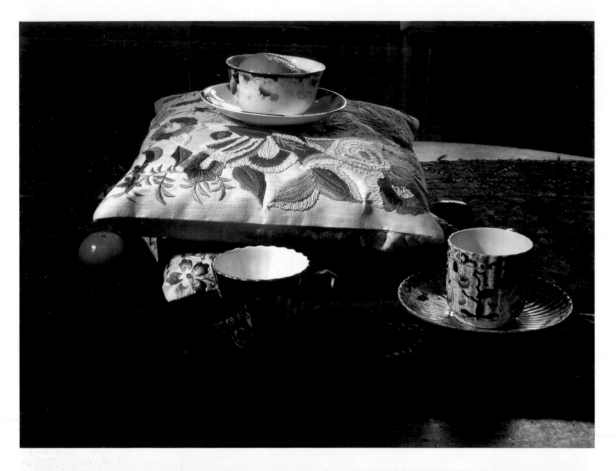

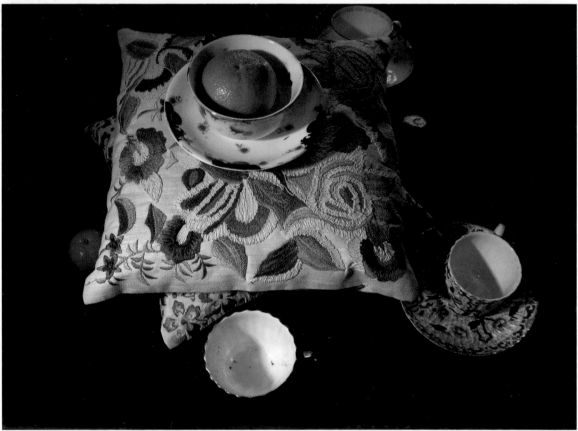

This composition has been photographed from different angles to illustrate how a change in viewpoint can alter a painting dramatically.

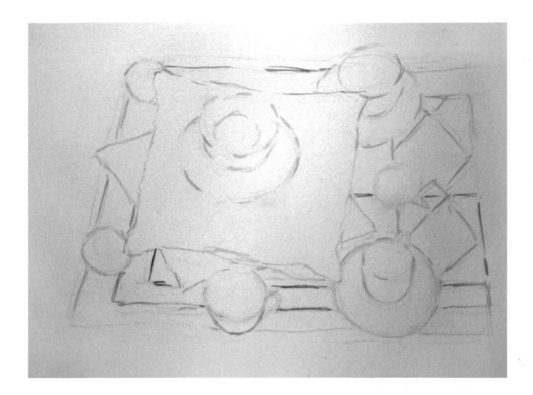

The composition is drawn with a pencil first and then some colour added.

The orange shades across the composition have been put in, plus some greens.

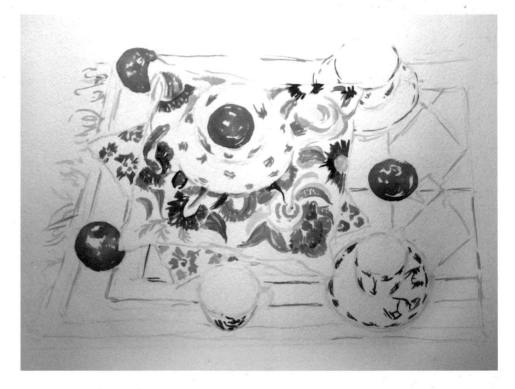

they are wrong, try turning your paper upside down or looking at the drawing in a mirror. By doing this you trigger the brain into looking at what is really there and not just what you think is there.

When you are happy with your drawing begin to paint.

Start by putting some colour on the satsumas, looking for the differences in shade on each fruit. It may not be very much but the variety adds interest. Work across the composition putting in any colour that is similar to the fruit, for instance, the pattern on some of the cups and on the cushions. In this way you are

**107**

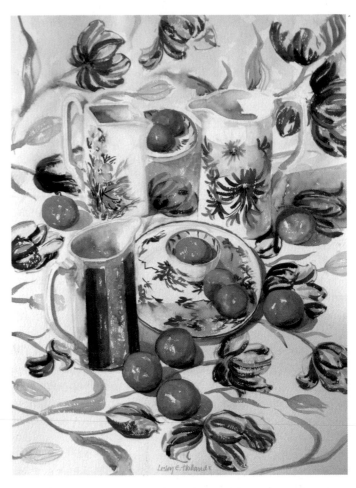

**Pattern on the cloth is added, along with some of the china.**

**The finished painting is bold and complex, but retains its fresh quality.**

Now you should be getting a feel for the whole group and how it fits comfortably on your paper. Stand back and check that all is as you want it. If you are working on a table, prop up your drawing board so that you are looking straight at it.

Begin to put in the patterns on the various pieces of china. An absolutely accurate copy of the pattern is not necessary but the colour must be right. Work from top to bottom so that you do not smudge one area while working on another. Build up the pattern on the fabric as well so that stronger colours are appearing across the composition and the balance is kept. Step back from your work frequently so that you are never far from what you are trying to achieve. Do not forget to change your water and clean your palette at regular intervals in order to keep your colours fresh and clear.

When all of the patterns are in, build up the colour on the satsumas to give them a greater degree of brilliance, keeping the strongest colour for the foreground. When this is done you are ready to start putting in the shadows. Before you begin on this, the most important part of the painting, take a long hard look at the shadows. You need to try and ascertain just exactly how the shadow colour changes depending on where it is and what it is near,. Look at how dark the shadow is in any one place and compare one area with another to help you to see all of these variations. Ask yourself questions such as: is the shadow darker nearer to the object? Does it have a hard edge, and if so is it hard all the way round or does it soften and fade out as the shadow moves further away from the object? Is the colour cooler or warmer? Does it tend more towards a blue tone or a purple? Does the shadow look different on the inside of the china to the outside? By asking yourself these questions you engage your brain as well as your eye and are far more likely to catch the complexities within the shadows than you are if you went straight into painting them.

Start with the shadows at the back of the painting, again to avoid smudging where your paint is still wet. Lay in the colours inside the jugs, getting the soft edge at the top which indicates the curved surface. Then work on the outside, running a damp brush down the edge of the shadow to fade out the colour. Do not worry if the pattern runs slightly – it is all part of what watercolour does and if it goes too far you can always sharpen

it up later when it is dry. A bit of diffusion further back in the painting can add a greater feeling of depth and interest. It is better to have variation in a composition rather than have everything painted up to the same degree of sharpness. Put in the cast shadows on the cloth and the green tones on the fruit. Your work is now nearly complete.

Stop and look once again and decide whether the cloth at the back needs pushing back a bit. If it does not look as though it is going up the wall behind the group then a little wash of colour, just to take the whiteness off, might help. Use a subtle shade of Yellow Ochre; you only want to make the cloth recede a little and sit back within the painting so don't overdo it.

The finished painting has a richness of colour contrasting with the brilliance of the satsumas and the delicacy of the china which makes it a most attractive piece of work.

## EXERCISE: STILL LIFE IN THE GARDEN

This is a slightly unusual still life as it includes a landscape as a background. It is challenging to paint outside, especially when it is very sunny which, of course, is when the best light and shade can be achieved. One of the difficulties is the reflected glare from the paper and of course wearing sunglasses does not work as they change the appearance of all your colours. A large shady hat can help and even better a parasol or the sort of umbrella that goes into a garden table. The umbrella has the advantage of not only shading your face but your paper and paints as well. Without any shade to work in the paint can dry very quickly making washes difficult. If you are working in a public garden or park you have the added difficulty of members of the public peering over your shoulder and making comments and suggestions. However, even with all of the problems it is a fun but testing subject to paint.

The still life here was set up in a garden with some old apple trees and a few chickens as background. It was decided to keep the group quite simple as with the English weather you never know how long the sun is going to last. Also it needed to be completed in one session as things could not be left out overnight and the shadows would change dramatically as the day goes on.

Fabriano Artistico Rough 140lb/300gsm on a glued pad was used for this piece of work with the following colours: Cobalt Blue, French Ultramarine, Indigo, Indian Yellow, Carmine, Sap Green, Olive Green and Titanium White.

The bright orange flowers were chosen to give a contrast to the deep blues of the china and also to pick up the colour in the hens. The cloth is a simple one with just a few embroidered flowers on it in colours which link up with the rest of the

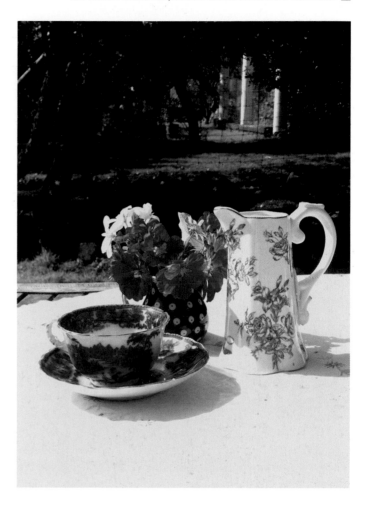

**A still life in the garden.**

group. There are three trees in the background that take your eye gently into the distance; three hens in the middle distance that just suggest a little movement and something happening and then the still life in greater detail, sunlit in the foreground. Having things in groups of three makes the group very comfortable to look at.

The still life was drawn out first, with the simple shapes of the trees and hens put in behind. As time was of the essence the flowers were not drawn, just a space left for where they should go. The hens were put in first as they could not be relied upon to stay where they were wanted for very long and they needed to be established ready for when the grass was put in. (Photographs had been taken in case they decided to disappear.) The grass was quickly washed in using a bright green mixed from Sap Green and Winsor Yellow, toned down in places with a little Raw Sienna. While this was still damp a darker broken wash was put in to indicate the dappled shade under the apple trees. This colour was made by mixing French Ultramarine into the bright green that had already been used.

**The composition is drawn out; the chickens have been made to seem nearer by making them larger.**

The flowers were put in next, going over the green where the wash for the grass had been put in a little too energetically, and then the pattern on the china was indicated. The taller jug has a paler shade of blue, which was made by mixing a little Cobalt Blue with French Ultramarine. The spots on the small jug were put in first with just a simple circle, so that they did not get lost

**The background has been painted in using a range of greens to capture the feeling of dappled sunlight.**

when the rest was painted. The cup and saucer were painted next. The cup and saucer are a very deep blue and a mixture of Carmine and French Ultramarine, with a very small amount of Indigo was used to achieve this. The willow pattern on the cup was not drawn first but simply suggested with a few brush strokes making sure that the pattern followed the shape of the curved surface. The simple pattern on the cloth was drawn in with a fine-pointed brush, using colours that were already a part of the composition in order to keep a degree of unity within the painting.

The shadows cast by the objects are very much on the blue side due to the strong sunlight shining on the white fabric. The shadows immediately underneath the objects are darker and slightly more purple in colour. By making the shadows very blue they enhance the feeling of it being a brilliant, sunny day. Shadows were put on and inside the cup, making sure that there were no hard edges which would make the objects look less round and keeping the thin precise edge of the rim free from paint. The shadow on the taller jug was run in from top to bottom to accentuate the cylindrical nature of the object and the left hand edge was gently softened with a damp brush. The small, spotted jug has a sweep of blue shadow run around it and a couple of small areas of reflected orange colour from the flowers. There is a very small amount of the reflected orange on the tall jug as well but do not overdo this as some of the effects of sunlight could be lost.

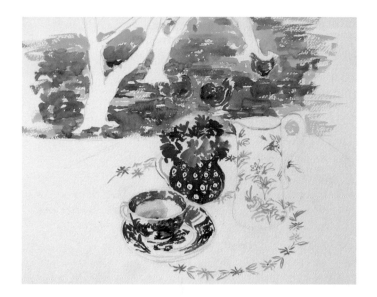

LEFT:
**The still life goes in next, with some of the pattern on the cloth.**

BELOW:
**The finished painting, giving the feeling of a bright sunny day.**

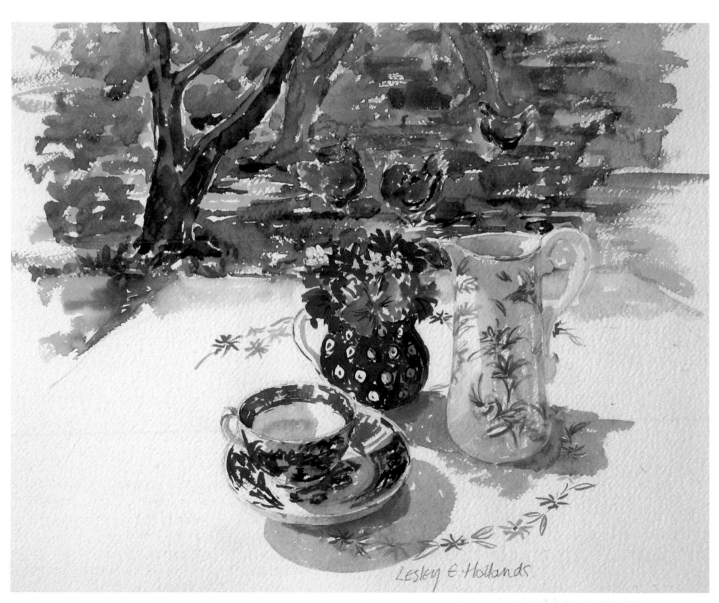

Now that the still life on the table is pretty much complete, it is time to work into the background. The garden needs to be pushed back and made to play a supporting role to the main still life group. The background also needs to be fairly dark in order to make the sunlit group seem even more brilliantly lit up.

The trees are washed in with a dragged layer of olive green and brown paint. The dragging gives just enough of a suggestion of the texture of the bark without overdoing it and the two colours give a gentle impression of light and shade. Some of this colour is also run into the grassy area to darken part of it and give a little more subtle variation. The chickens have some shadow put under their wings and a touch of colour on their combs. They have some white feathers on their tails and these have been put in with a mixture of Titanium White and Naples Yellow. The white on its own would have stood out too much. Finally, the back edge of the cloth is softened by running a little pale blue shadow colour across it and allowing the grass colour to run into it as well.

The finished painting is interesting and has the unusual combination of both still life and landscape. The chickens pecking in the background add a further appeal. A cat or some other living creature could play the same role here. If you were very brave you could try a seated figure just suggested beneath the trees, perhaps further back in the composition than the hens are.

## EXERCISE: TISSUE WRAPPED

This is a small but challenging composition to tackle. Getting the crisp feeling of the tissue paper and making it look semi-transparent is where the difficulty lies. The tissue paper has been wrapped around the fruit and then allowed to open up enough to show the satsuma inside. It has been placed on a white cloth so that the colours in the shadows and any reflected colour from the fruit can be seen to their best effect.

The tissue paper has been drawn using straight lines, which keeps the crisp feeling of the paper and the satsuma placed so that the paper goes across it just slightly.

The paper used here is Fabriano Artistico Rough 140lb/300gsm with the following colours: Indian Yellow, Permanent Rose, Cobalt Blue and French Ultramarine. The rough paper makes it easier to show the texture on the surface of the fruit.

The satsuma is painted first with a mixture of Permanent Rose and Indian Yellow, dragging the paint to get the texture and leaving the highlight as white paper. There is quite a lot of reflected colour from the fruit and this is put in next so that it does not get lost. Vary the colour so that it is more yellow in front of the satsuma where the colour is lightened slightly by the white of the paper and more orange on the creases nearer to the fruit. Put in the shadow on the satsuma, making it soft-edged at the front where it comes around the curve of the fruit and slightly more hard-edged at the top where there is a clear shadow cast by the paper.

The shadows on the paper have a lovely range of subtle colours, all very delicate and understated. It is important to keep some of the edges of the shadows as straight, hard lines in order to indicate the crisp edge of a fold. Other areas of shadow have a softer edge to show the gentle curve of the paper where it moves around the fruit. Build up these shadows

**Tissue-wrapped satsuma showing reflected colour.**

The composition is drawn out with delicate lines.

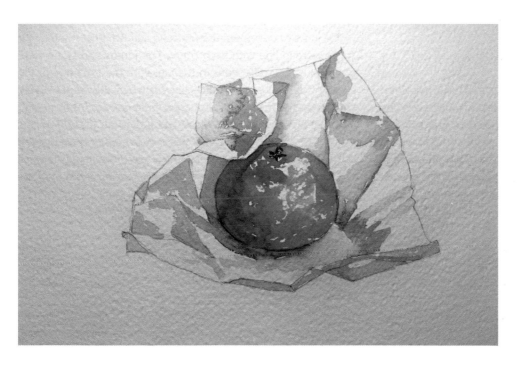

Look for the range of colour in the tissue paper and reflected colour from the satsuma.

slowly and carefully as, if you put too much in, the paper will end up looking as though it is coloured and opaque rather than transparent and white.

When all the shadows on the paper are complete, the cast shadows can be put in. There is quite a lot of light shining through the paper so a white area is left at the front with reflected yellow and orange around it. The shadows cast by the paper are stronger than those on it, but are still quite delicate and display a range of colours.

When all of the shadows are in, check that the orange colour on the fruit has not sunk and if it has give it another broken layer of paint. You may also need to darken the shadow immediately underneath the satsuma to ensure that it is sitting firmly in the paper.

This looks like a relatively simple painting but it needs some skill and delicacy of handling to make it work. If you can treat it with the lightness of touch that it requires it makes a delightful painting.

The painting is completed with shadows and is shown here with and without the extra colour on the cloth, both of which have their merits.

yellow from the background through to the china. Use the Indian Yellow and some Raw Sienna to get the different shades and leave sections of white paper showing for the highlights. The pattern on the little pot uses the same blue as the cloth but in a more dilute form.

The red bead has nearly disappeared in this group but it still has a role to play by adding that small extra something that is not noticed immediately. The red of the bead is slightly darker than the Permanent Rose that it is resting on and it has a useful small area of highlight giving it a shine.

Shadows are dealt with next and the dark keynote of the shadow on the inside of the little pot is important as it is nearly, but not quite, as dark as the blue on the fabric thus bringing the deep blue forwards and balancing the composition. The shadow inside the cup is a little lighter but a similar shade of bluey green. The shadows cast have a rich purple tone that softens and unifies the pattern on the cloth.

When the shadows are in, stop and leave your work for a while. When you return there is one last area that you need to make a decision about. The fabric is not white but has a pale biscuit colour, which so far has not been put in. You need to decide whether the painting needs this extra colour or not. By putting it in you lose some of the contrast and boldness of the fabric but the china will stand more because they will be the main area of light. By leaving the cloth as it is you retain the contrast in the background and keep the strong vibrancy of colour, but the china does not have as much impact.

It was decided, after some consideration, to put the extra colour in the background in order to make the china more dominant within the composition – you can judge for yourself which you prefer.

The finished painting has a warmth and boldness to it which is very attractive.

## EXERCISE: ARRANGEMENT ON A PERSIAN RUG

The next painting also has a very strong background.

An old Persian rug has been used to set off this arrangement of china, fruit and other odd objects, giving a slightly quirky composition. The shapes have been chosen very carefully and the way they have been assembled has also been given great consideration. The following three photographs illustrate how changing the position of the objects, even if only slightly, can have a huge bearing on the composition.

In the first photograph below all of the objects are contained within the area of the rug which makes the composition seem rather tight and constrained.

The bowl in the second photograph (overleaf) has been moved forward, breaking the line of the front edge of the rug and opening up the composition slightly. Having the bowl in the foreground helps to take your eye into the composition but there is still a rather long line of rug showing and not an interesting area of white cloth.

The final photograph (overleaf) shows the two stones placed on the white cloth, but just overlapping the edge of the rug, thus breaking up the edge and improving the rather blank area of the white cloth.

The composition is made up of a series of curves created by the ellipses of the china, the back of the china cat, the edge

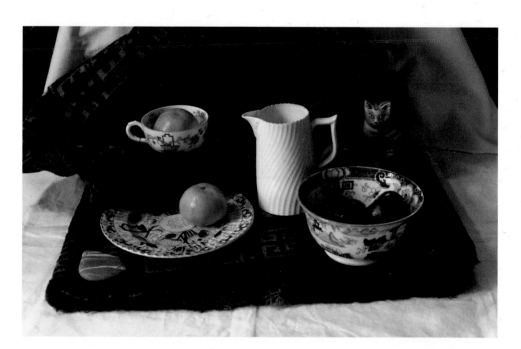

**All the objects contained within the rug, giving a rather tight feel to the composition.**

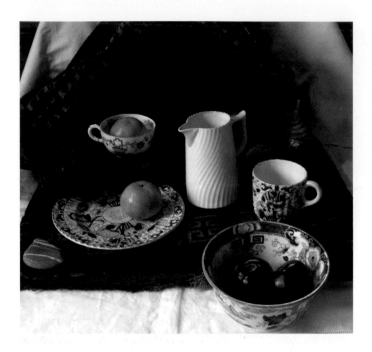

The bowl breaks the front line, which is an improvement but not quite enough.

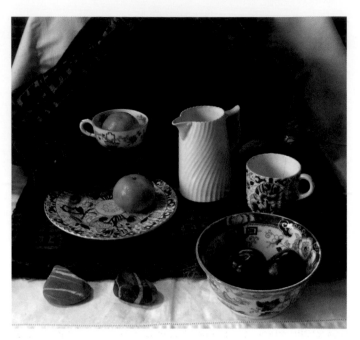

The final choice of composition.

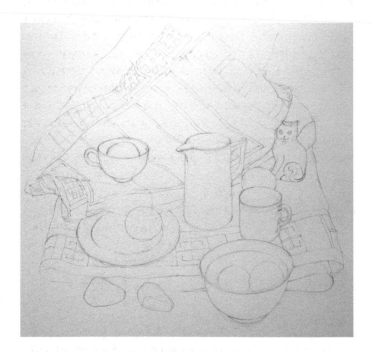

The composition is drawn out with care as it is quite complicated.

The bright oranges across the painting are put in first.

of the stones, the plums and the satsumas all of which are echoed by the soft curves and rich folds of the rug. Not all of the objects are seen in total; the cat is partly hidden by the rug as is the back of the plate and the cup nestles in a fold in the rug. The colour choice was important and the positioning of the satsumas to take the brilliant orange through the group

was carefully thought out, as was the placing of the plums in the bowl which brought some of the dark colour through to the front. The china cat adds an amusing note and has been intentionally placed so that it is tucked away in the background, appearing to watch the rest of the group. The colour of the cat, which is a lighter version of the satsumas, has also been

carefully thought through. The china has been selected because of the splashes of orange on it which, while giving a different shade, still connects with the bold splashes of colour from the satsumas. The rug itself has some touches of a duller orange amongst the deep brown, red and navy blue which keeps the colour theme running through the composition.

There has been no pretence about the make-up of this composition. It is not a natural grouping, but something that has been carefully orchestrated to be interesting and pleasing to the eye – with dramatic colour and tone.

Fabriano Artistico Not 140lb/300gsm on a glued block was used for this painting with the following colours: Carmine, Alizarin Crimson, Permanent Rose, Burnt Umber, Indigo, French Ultramarine, Indian Yellow and Raw Sienna.

This composition is large and complicated. The pattern on the rug plays an important part as it shows how the rug has been folded and indicates the various curves and changes in direction. The china gives a range of hard-edged curves against the softer, more fluid shapes of the rug and the stones, although curved, have a less distinct and more organic shape.

Take your time drawing out the composition. Put in the china with just a slight indication of where the pattern needs to go. Draw out, again lightly, the folds in the rug and start to put in the main shapes of the pattern. You may well get slightly bored putting in the entire pattern on the rug in one go, as it takes several hours of work. If you find yourself losing focus then stop and either leave the painting for a while and do something completely different or start applying colour.

Paint the various objects first as these need to stand out against the dark and dominant background. The satsumas are painted with a mixture of Permanent Rose and Indian Yellow, which gives an excellent clear orange. By varying the proportions most of the other shades of orange in the painting can be achieved. The cat is painted with a broken wash of a paler orange, leaving the white paw and tip of the tail as white paper. The stripes will be put in later using an orange mixed with Burnt Umber. The bowl has a shade of blue very similar to the dark blue in the carpet. To help the bowl stand out a slightly lighter, brighter shade of blue is used, created from a mixture of Indigo and French Ultramarine.

The two stones have softer versions of other colours in the composition. The pink stone colour was made by mixing Carmine and Indigo with a touch of Burnt Umber all in a fairly dilute form. It is painted so that the white stripes are left as white paper and the lines curved to indicate the shape of the stone. The darker stone is Indigo with French Ultramarine, again quite dilute and the white stripes left as white paper. You could, of course, use masking fluid for the stripes or put them in afterwards with Titanium White but neither of these methods are as effective as leaving the white paper.

You can see that the composition is being worked right the way across; this is so that the right balance of tones can be kept more easily.

The plums are the darkest part of the foreground and are again going to help bring the bowl towards you. Keep the shine on the fruit by leaving the highlights clear of paint and make sure that you mix a good rich colour that is not going to dry lighter than is needed. A broken wash of Carmine is put down first and then a wash with a mixture of Permanent Magenta and Carmine with a little Indigo added to create the very darkest areas.

The plate and the nearer cup have black lines on them as part of the pattern and these are put in using Blue Black and Indigo.

Now the brightest and the darkest colours in the objects have been painted and it is time to start work on the carpet. You could put a wash of brown over most of the rug and then put the other colours in afterwards, but this can create a rather heavy and overworked appearance. A better and fresher way is to start with the brown which is the dominant colour, but paint around the patterns that are in other colours. By doing it this way it is easier to leave those all-important flecks of white paper showing and to vary the shade of brown as you go. The rug has an almost velvety surface and naturally has a subtle range of colours in it as it is old and handmade. By mixing and changing the colour as you go the velvety effect is easily realized. Burnt Umber, Carmine, Alizarin Crimson and Indigo are used in varying proportions and combinations to achieve the colour of the rug.

Start on the top left-hand side if you are right handed or vice versa if you are left handed, so that you avoid smudging the wet paint. Don't worry about making the colour darker where it is in the shadow as this will be put in later.

When all of the brown has been painted in, start on the other areas. Mix a range of soft reds and oranges for the small areas that have these colours. Even though there is not a large area of any one colour it is better to have a range of shades as it adds to the richness of the rug. The dark blue is a mixture of Indigo and Blue Black. Some parts of the pattern have a light cream colour to them which acts as a foil to the rest of the design. Dilute Raw Sienna in a range of strengths is used for these areas.

It is very important that all of the rich, deep colours in the rug are made as dark as they really are. If you lighten them you will lose a lot of the drama and impact that the carpet gives as a background to the lighter, brighter tones of the objects placed on it.

Once the entire pattern on the rug is complete, stand back from your work and look at the overall effect of the dark background against the brighter objects. Ask yourself if the contrast is strong enough or whether any areas need to be deepened? Do the satsumas glow against their surroundings or do they need an extra layer of colour to bring them out? Are the plums bold enough or do they need to be darkened?

Make any adjustments that are necessary and then put in the shadows.

The pattern on the china is added next, along with stones.

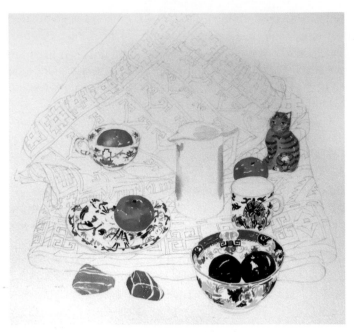

The plums and other dark blues are next.

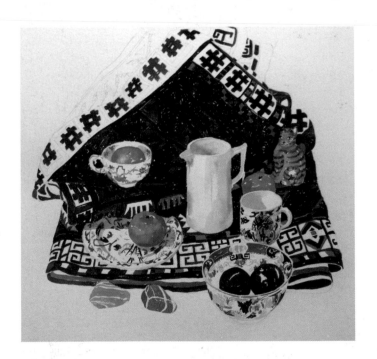

The rug with its rich colour and intricate pattern is painted in with care, along with some of the shadows.

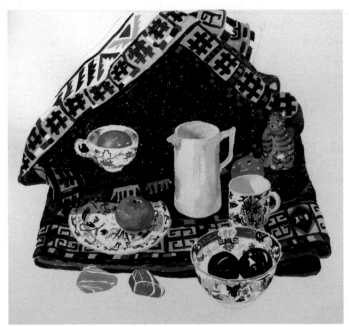

More rug.

The shadows are going to explain the folds in the rug and subsequent change in direction of the pattern. They are also going to make the various fruits sit properly where ever they are and push the cat into the background. The shadow cast by the rug is darker at the front than towards the back which will help to bring the front edge towards you.

For the shadow to show up on top of the rug, quite a dark colour will be needed. Mix a combination of Indigo, Carmine and a little French Ultramarine for the darkest areas behind the jug and the cat. Use less Indigo where the colour is lighter. The shadows cast by the bowl and the stones vary in colour from a soft red through blue to purple. Do not overlook this

range of shades or some of the subtlety of the foreground will be lost.

The shadows inside the china and on the satsumas also have a range of tones. The bowl is much bluer in colour and the rest of the china looks yellower, partly because of reflected colour from the satsumas.

When all of the shadow on the composition is in place you need to make a decision about the white areas on either side of the rug. There is quite a strong shadow cast by the rug on the right and a smaller but quite dark shadow thrown by the fold on the left. This still leaves a large triangular blank area on the top left and a smaller triangle on the right. If they were left as white paper they would stand out too much. Here the whiteness has

been taken off with a broken wash of Raw Sienna, which links with the colour in the rug, and the addition of a touch of French Ultramarine which has been encouraged to run into the Sienna to create a soft, overlapping colour.

This was a challenging composition to paint with the different surfaces of the rug, fruit and china, almost all with pattern on and also some very strong colours to deal with. The finished painting works very well with its dramatic contrasts, triangular shape and slightly curious choice of objects.

**The painting is finished and glows with colour.**

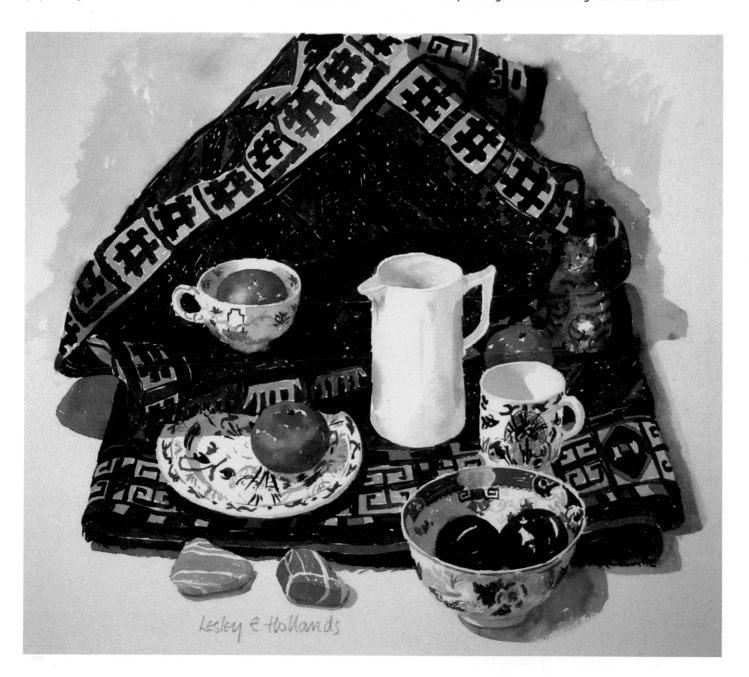

131

# DEVELOPING YOUR WORK TOWARDS ABSTRACTION

Once you have mastered some, or all, of the many and varied techniques described in this book so far, you may well feel the urge to break away from the more conventional approaches to still-life painting and try some new methods. The following ideas are suggestions to get you going and begin to 'think outside of the box', but the more you experiment the more you will find your own individual style of painting and your own personal approach.

There is also a number of new mediums on the market designed for watercolour that can give you some very different effects. A number of companies make them including Schmincke, Winsor & Newton and Daler Rowney:

■ **Thickening Medium:** sometimes called *Aquapasto:* this gel is transparent and thickens the watercolour allowing you to achieve three dimensional effects. It can be built up in thin layers or put on in one thicker layer. Using a palette knife gives good results. This medium also increases the shine and therefore the brilliance of the colour.

■ **Aqua Modelling Paste:** this comes in a fine or coarse finish and can be applied with a palette knife or finger to give three dimensional effects. The paste when dry is painted over.

■ **Aqua Collage:** this increases the adhesion of lightweight collage materials such as tissue paper, fabrics, sand and so on. It stays water soluble unless mixed with *Aqua Fix*, which makes it waterproof.

OPPOSITE PAGE:
**Jugs and pattern (detail).**

■ **Texture Medium:** contains fine particles and can be used to give an impression of depth and structure. Useful in a limited way for tree bark and beaches, it can also be used in abstract work to give greater variety to the surface of a painting. It can be mixed with watercolour or applied directly to the paper.

■ **Granulation Medium:** this gives a mottled or granular appearance to watercolours useful in backgrounds, landscapes and abstract work.

■ **Iridescent Medium or Aqua Shine:** these products give a pearlescent or shimmering effect. They can be mixed with watercolour on the palette or applied directly to the dry painting. Useful when depicting some shiny surfaces or working in a more abstract way.

■ **Finishing Mediums:** watercolours can be quite sensitive when finished and even with today's much-improved pigments some colours are still fugitive. There are a number of ways of protecting your work. First and foremost they should be mounted with acid-free card and put behind glass in a sealed frame which prevents dust getting in. Paintings should then be hung out of direct sunlight.

If these precautions are not possible or as an added protection the following products are available.

■ **Aerospray:** this is a fixative for watercolours, which protects them from fingerprints, humidity and dust. If it is applied in a thin layer it does not change the colour.

■ **Aerospray Universal Fixative:** this has UV-protection and gives a non-yellowing, clear, satin finish.

■ **Aerospray Matt Varnish:** a fast-drying protective matt varnish in spray form.

The black on the cat balances the black pattern and the jug adds subtlety.

Extra colour brings the composition to life.

After some thought, it was decided that the yellow on the fish was needed as it continued the colour across the painting. The shadows were also important and needed to go in after the fish were complete. The floral fabric was still an area of doubt so it would be left for the time being as was the addition of further colour to the fabric on the left.

The fish was painted using two shades of yellow and then the shadows on the objects, which makes them look very three dimensional. The background to the cloth on the left was put in using dilute Raw Sienna which, with the other work, pulls the painting together rather well. This leaves the decision of what to do with the floral cloth. It was decided to adjust the colour slightly from the original, which had a lot of purple and mauve in it, and use variations of colours already used in the composition. The green in the embroidery was made either more yellowy or more bluish in order to connect the colours with the

The embroidered pattern links the two sides.

The extra strip of black pattern brings the composition together and giver greater balance.

rest of the painting. To have used the bright green from the original would have made the fabric stand out too much and be more dominant than was wanted.

It is time to reassess once again as the painting is very nearly complete and the final touches need to be the right ones. The composition continues to work well and the only area that needs further work is the top right-hand corner which looks rather empty. A number of things were considered as possibilities for this part of the composition including stripes, checks and more pattern from the African fabric. After much thought the African cloth pattern was chosen. A section was drawn in lightly to begin with and expanded until it comfortably filled the space. The way in which the design went behind the cat and the fish was carefully considered as was how the top edge followed through with the edge of the rest of the fabric. It was then painted using the same colours as the other section of the cloth.

The finished painting works well on a number of counts; it has contrast, and rich as well as delicate colour; the objects are interesting as individual pieces and as a group; the painting has a touch of humour from the choice and placing of the objects, and not everything is noticeable immediately. It was great fun to put together and to paint.

## A FURTHER STEP TOWARDS TOTAL ABSTRACTION

This is a far more challenging way of working and will need plenty of thought and imagination to carry it through.

Put together a composition of objects, fabrics and colours that you enjoy working with and are visually excited by. Fairly large, bold shapes work best with this approach. Using a large sheet of paper, A1 or A2 ideally, draw out the composition so that it fills the page. Now give the paper a half turn and redraw a part of the composition to a larger scale, overlapping some of the original drawing. It will appear complicated but do not be put off. Keep your lines clean and clear but not too heavy at this stage. Prop up the drawing and step back from it so that you can have a good hard look at what you have. The next stage is to work into the drawing, away from the still life group, by selecting the most interesting areas created by the overlapping shapes and the spaces between, then redrawing the lines more clearly. You need to do this slowly, considering the whole composition as you work into it. Because it is such a large size you may find it easier to work on an easel or at least with the board propped up across a couple of chairs. Stepping back frequently is then a much easier proposition. You are aiming here to create

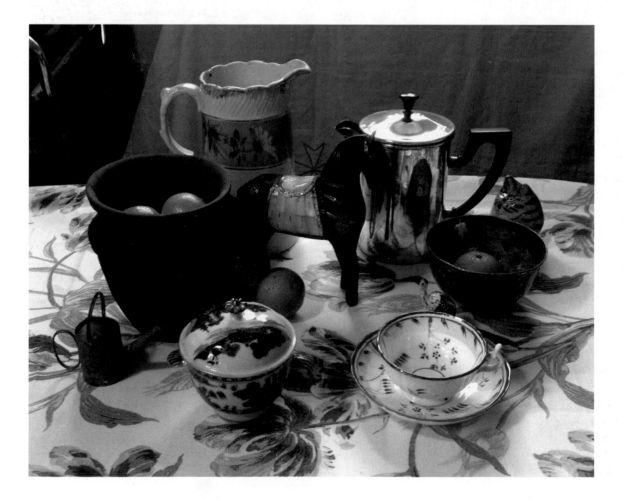

The strange collection of objects assembled for the next abstract composition.

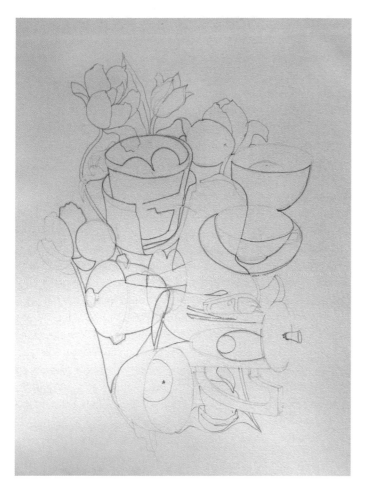

**The drawing is complex but still clear.**

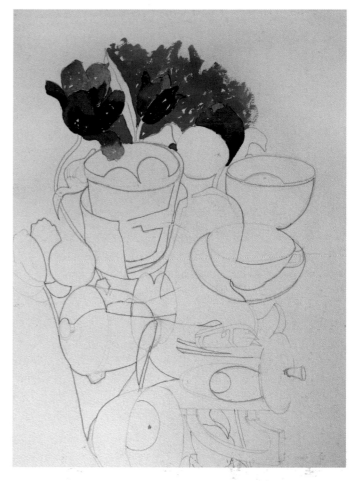

**Colour has been put in at the top to avoid smudging.**

a new and vibrant composition made up of bold but interesting shapes. You may well need to rub areas out and redraw or even go back to the still life and select new areas to include.

When you are satisfied with the drawing you need to consider the colours that you wish to use and your chosen method of applying the paint. Some of the important questions that you need to ask include:

■ How shall I use the pattern in the composition?
■ Do I want the finished painting to look flat or 3D?
■ Would outlining areas enhance the drawing and add an extra dimension?
■ Does it matter that the objects from the original still life are no longer recognizable?

When you have answered these questions start to paint. Begin with areas away from the centre so that if you are not happy with the effect it will not spoil the rest and at worst can be removed by trimming the paper.

Fabriano Artistico Not 140lb/300gsm has been used for

this painting with the following range of watercolours: Blue Black, Indigo, French Ultramarine, Cerulean Blue, Cobalt Blue, Carmine and Indian Yellow.

It was decided to limit the range of colours to shades of blue, plus orange and black in order to achieve a degree of unity but with some contrast in both colour and tone.

Not all of the objects put out were used in the drawing as they did not seem to be needed. There is of course no reason why you should not add or subtract items from this sort of composition at almost any stage. It is a fluid piece of work and can be treated quite freely and intuitively.

The first stage is to decide in the broadest terms how you want to tackle this painting. Do you want to move away from filling in shapes or do you want to start in that way and loosen up later? Will you add pattern into areas in some way or leave the shapes as flat areas or a combination of the two?

It is best to allow as much room for flexibility and mind changing as you can at this early stage. It is very important that you keep an open mind and be aware of the possibilities that arise at all times. To do this, continually appraise your work,

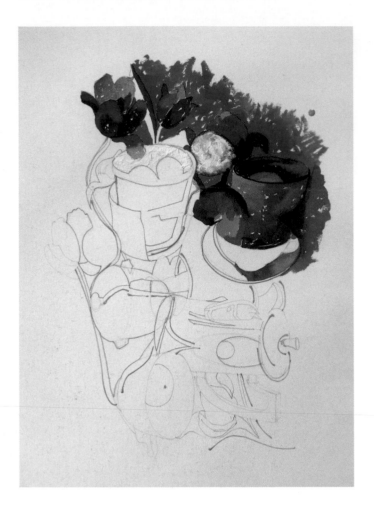

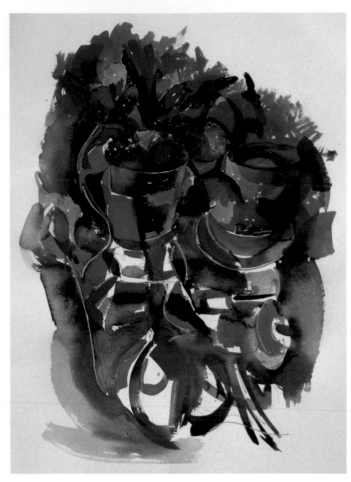

**More colour and some masking fluid lines go in next.**

**The colour is going on more loosely now.**

prop it up and stand back so that you can see it as a whole and do not rush into things. It is a free and intuitive piece of work which does not mean that it has to be painted quickly.

On looking at the finished drawing, when some of the secondary lines had been added, it was decided that the composition worked best in portrait format.

The painting was started by putting in some shades of orange at the top of the paper. This area was kept as a broken wash so that the white of the paper showed as small flecks. Larger adjoining areas were then painted with shades of blue, aiming to give some feeling that the shapes were three dimensional by the way the range of colours was used. It was beginning to feel a bit like painting by numbers as the shapes were just being filled in, all be it with interesting colours. To counter this, the paint was encouraged to run so that some edges became diffused while others were kept crisp.

To get a hard edge, leave the first colour to dry before putting the next colour down beside it. To achieve a mingling of the colour put the two down side by side while they are both still wet. You will find that some colours are more dominant than others and will push into the weaker colour. Experiment to find out which colours in your palette will do this. To soften too hard an edge, drag a wet brush down the join. This will only work with colours that will dissolve again after they have dried.

By running the blue into the orange softer shades of brown were created, giving a wider range of tones and colours and a greater degree of subtlety.

At this point the work was propped up and scrutinized from a distance. Where the paint was moving into other areas it seemed to be working but the top middle, where the painting started, seemed dull. To counter this, a layer of Schmincke coarse primer was applied to some areas. This can be put on with a palette knife or a brush; just make sure you wash whatever you use before the medium has a chance to dry. The primer gives an interesting, rough surface and can be applied over an area already painted or directly to the paper. It is best to be working on a fairly heavy weight paper that is not going to bend too much in order to prevent the primer cracking and coming away. The medium must be left to dry before working on top of it.

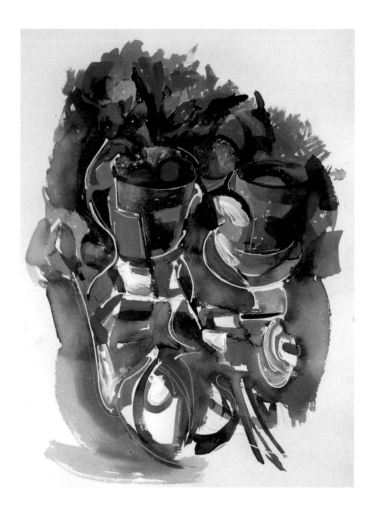

**Extra lines of silver have been added once the masking fluid is removed.**

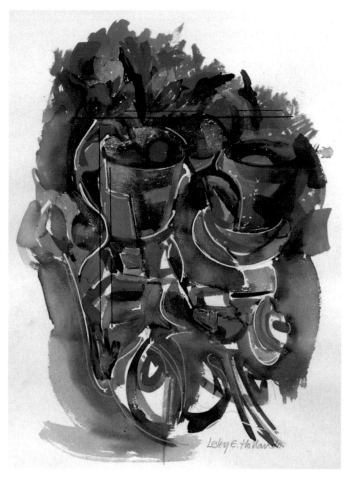

**Dark lines give a degree of formality and some contrast to all the more flowing lines.**

At this stage it was also decided that some lines of white running through the composition would be useful. These were drawn in with Schmincke blue masking fluid, which comes in a useful tube with a nozzle to apply it. The lines run right through the composition, echoing some shapes and emphasizing others. It does not matter if you mask out more areas than you think you might need as they are very easily painted over at a later stage.

The painting still was not as lively as it could be so some really large brushes, approximately 4cm (1.75in) across, were found and the plates that were being used as palettes were cleaned and fresh paint put out. Standing up, with the painting resting on a low table and the brushes held at the top of the handle, made it much easier to paint freely and fluently. A separate brush was kept for the blue palette and the orange palette in order to prevent the colours becoming muddy. Some broad lines of colour were taken down into the lower parts of the composition, using a range of shades and working with the lines that could still be seen from the original drawing. The width, length and strength of line were varied to give further strength and interest to this area.

More reds and yellows were added to the colour range as just having Carmine and Indian Yellow seemed to be unnecessarily limiting. Permanent Alizarin Crimson, Permanent Rose and Winsor Yellow were put out plus a little Naples Yellow.

The additional colours added a range of subtle purples and more shades of orange to the range.
More areas of colour were added across the painting with the overall effect being considered regularly.

The painting is steadily becoming more exciting and interesting and the danger now is that we might go too far and lose the balance and freshness of the composition.

If an area has gone too far and seems to be lost there are one or two things that can be done to rescue it; masking out with a layer of Schmincke fine primer, putting on two to three layers and waiting for it to dry before painting will take you back to a white surface; using collage in the form of tissue paper or newsprint, if glued on the back only will allow you to repaint on top; paint over with opaque watercolour, gouache or, as a last resort, acrylics. If you use acrylics you will not be able to paint over with watercolour as the acrylic acts as a resist.

The masking fluid is removed to reveal the fine white lines drawn across the painting. These work well and just need toning down in a few places and emphasizing in others. A silver marker pen, which only shows as a quite subtle line, is used to echo some of the white lines and delineate new parts of the drawing. Some extra texture is added in the lower part of the arrangement to balance the previously applied rougher areas. These are left to dry while the whole composition is considered once again.

A little more colour is added to reduce the amount of white in the painting and some darker areas put into the lower part to counterbalance the heavier colours at the top.

As a finishing touch some dark strokes could be used to pull the composition together and add some straight lines to act as a foil to all the curves. Before taking this sort of action, which is difficult to undo, cut some thin strips from a sheet of black paper. If you don't have black paper, paint a sheet of white cartridge black and cut that up. Lay the strips across your work so you will get an idea of how the lines will affect the composition and try out various combinations. The lines do not have to go right the way across but could stop at the edge of a shape and continue on the other side. They also do not have to be the same width, length or have the same degree of intensity.

After trying out various combinations a final decision was made and the lines were drawn in using a thick, black marker pen.

This painting was fun to do but nerve racking as well as it could have gone in so many directions. Having to rely on your own artistic and creative sense makes you think very hard about what you are doing and what you want to achieve, but working in this way opens your eye and mind to the range of interpretations that any still life can have. It is a colourful piece of work, perhaps too bright for some and it would be interesting to try something similar but using far more subtle and muted colours.

## EXERCISE: A GROUP OF JUGS

This is a variation and development of the previous two compositions. Jugs have been chosen because they have a pleasing shape which gives a unity to the composition but enough variety to add interest.

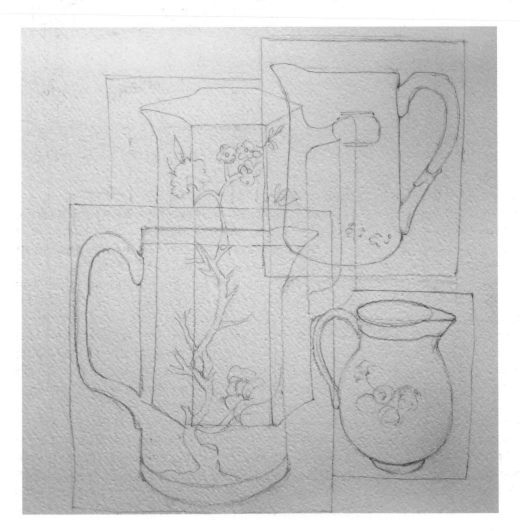

**The composition is drawn out using the rectangles as a guide.**

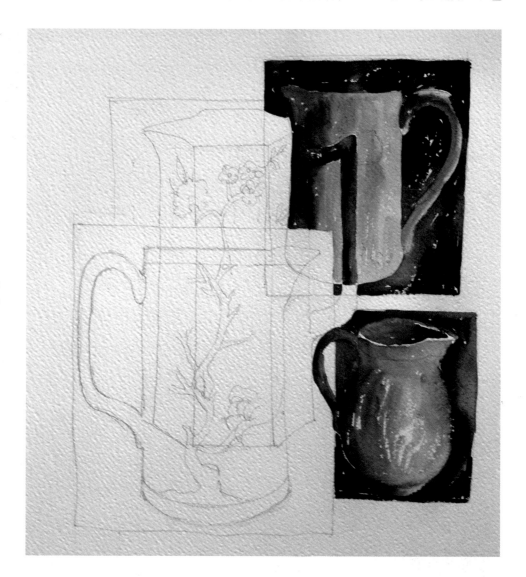

**Dark blue in the background gives a dramatic contrast to the lighter jugs.**

Start by dividing up your sheet of paper into rectangles of different sizes to suit the proportions of the jugs that you have chosen. Draw the shapes out so that they use up the space and make a balanced and comfortable division of the sheet of paper, making the areas overlap in places. Keep the pencil marks light as you will probably need to adjust the size and position of the sections.

This drawing was started in the top right-hand section and the jug was drawn looking at it straight on so that the top becomes a straight line and the base is curved. Further jugs are added, each time adjusting the rectangle around them and varying the viewpoint so that with some you can see into them and others you cannot. When you are happy with the composition and the way that the jugs overlap each other and fill the space you need to decide which colours to use.

It was decided here to use a limited palette of Sepia, Burnt Umber, Raw Sienna, Yellow Ochre, Naples Yellow and Indigo. The work was painted on a sheet of Fabriano Artistico Rough 140lb/300gsm.

There are a number of different approaches that could be taken with a composition of this type; it could be painted in quite neatly making use of the variety of shapes, created by the overlapping lines of the jugs and their confining rectangles, to give interest; it could be painted much more freely, allowing lines to blur and merge with surrounding areas; or it could be a combination of both of these approaches.

The chosen method here was to start by filling in the shapes but at the same time allowing movement of the paint by laying in colours next to each other while they were still damp. In this way there is quite a high degree of control but the mingling of colours gives some intriguing effects.

The background to each jug is kept quite dark in order to throw the shapes of the china forwards. The dark is varied by either starting with Indigo and then dropping in Sepia or starting with Burnt Umber and adding both Indigo and Sepia where a very dark area is wanted. Work across the composition in this way, gradually building up the jugs and their backgrounds.

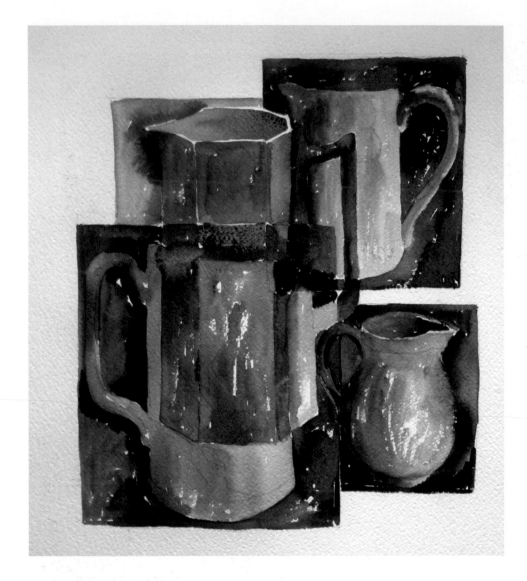

**More variation is added by using the lines to divide the colour.**

Keep standing back from your work and assessing the effect of each addition. Do not worry if it all looks a bit tight at this stage as it can be loosened up later.

When the basic painting is completed the next step is to consider the background. There is not a lot of space between and around the rectangles but what space is there is important. Again, there are lots of different ways of using the background; it could be kept quite simple and filled in with a wash of one colour; it could be washed in with a range of tones so that it goes from light to dark, top to bottom or vice versa; a pattern could be put in, perhaps an extension of one of the designs on the jugs or something completely different; collage techniques could be interesting here with the use of different papers and surfaces, although you would need to make sure that this did not dominate the rest of the composition.

After much thought it was decided that a combination of washes of colour and some pattern would work well. A narrow range of opaque shades was mixed using Cobalt Blue, Titanium White and Naples Yellow. These were used to put in a rough approximation of the pattern on one of the jugs, working along the bottom of the painting to begin with and then taking the design up on the right- hand side. By taking the pattern over the bottom edge of the rectangles around the jugs the shapes are incorporated into the background and give a greater degree of unity. The top and left-hand side of the paper was then wetted and some Cobalt Blue dropped in and dragged over the other edges of the rectangles.

The painting was then left to dry.

On going back to the composition after a break the painting still did not look as unified as was hoped. The patterns on the jugs had sunk slightly so were redrawn with some more opaque shades of blue. The edges of the jugs looked very hard and over defined, which was not working visually, so a large chisel-ended brush was used to encourage the colours to run into each other. The brush was dipped into clean water and with a fluid downward stroke, the paint was dissolved enough for it to

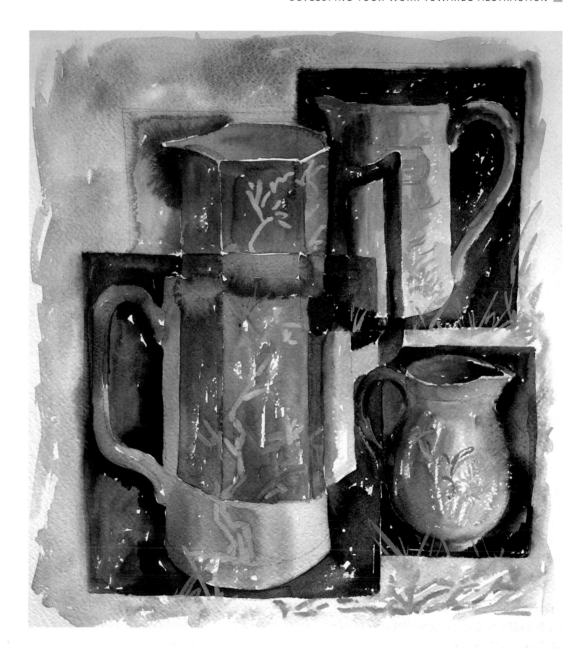

**The finished painting is pulled together with the addition of a background.**

flow into surrounding areas. This sort of thing needs to be done with confidence and a good decisive action. Nibbling away at the edges makes untidy, fussy marks which detract from the composition rather than pulling it together. Practise on a spare piece of paper if you are a little nervous about doing this sort of thing and remember that areas can always be repainted if the colours run too far.

The completed painting is interesting and unusual. The areas where the paint has dissolved and the original drawing almost disappeared are the most successful parts of the composition. The background to the handle on the left hand side, for instance, has a great feeling of depth to it as does parts of the small jug at the bottom right. The overall effect is bold but subtle.

## AN ABSTRACT STORY

This final painting is a mixture in a variety of ways. The subject matter is unusual in that it combines a portrait with a still life. The young man in the painting lives in the country but has travelled widely. The painting tells a story and has been put together like a jigsaw with objects fitted into spaces of an appropriate size and shape. The various objects all have associations with his life, interests and where he has been. The painting has used a range of media including collage, water-soluble pencil crayon, Conté crayon, pen and ink and watercolour.

The portrait has been put at the bottom of the paper to give the effect that the other things in the composition are coming from him and also to give plenty of room to develop

**The first stage using coloured crayons.**

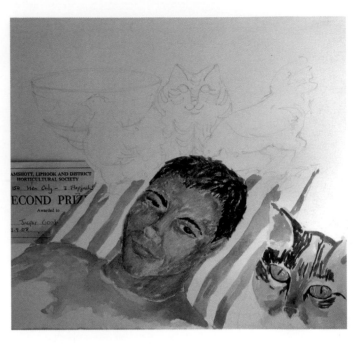

**Collage and paint go on next.**

the painting without feeling cramped. When the composition is complete any excess paper can be cut off.

Saunders Waterford Hot Pressed Paper has been used here as the smooth surface allows for finer and more detailed drawing. The following colours have been used in crayon form and watercolour: Yellow Ochre, Raw Sienna, Sepia, Burnt Umber, Carmine, Permanent Rose, Cobalt Blue, French Ultramarine and Blue Black.

The composition has been drawn out in part with the idea of adding more things as they come to mind. The portrait is the key to the painting so that is drawn in first and then the chickens and cat added next. The Uzbekistan bowl comfortably fills a space on the left-hand side and the wooden cat sits happily between the two chickens. The real cat is put in the foreground as he is an important part of the young man's life. On the bottom left, part of a prize certificate has been stuck in. The certificate has been cut to fit with the surrounding shapes. When gluing things onto a watercolour painting make sure that you do not get any glue on the top surface of whatever you are sticking on. Many types of glue will act as a resist to the paint, which can be very annoying when you had planned to colour over the addition. The way around this would be to use acrylic paint, oil pastels or crayon instead of watercolour.

You do not need to complete the whole of the drawing in one go as this is the sort of composition that grows and changes a bit at a time. When a section looks comfortable begin to add colour. Here the portrait was worked on first, partly because it is the most difficult part but also because it is the area of least experience. By starting here, if it goes badly wrong you have

not wasted too much time and you can then cut it off and use the rest of the paper.

The skin tones have been put in with water soluble crayons using overlapping shades of Yellow Ochre, Burnt Umber and Carmine. These colours have then been blended together with a wet brush to give a smoother appearance. The colour has then been adjusted where needed with thin washes of watercolour.

The cat has been put in next and then the chickens with their colourful feathers. The Uzbekistan bowl has the same colours as the tee shirt and cushion, which brings the blue through the composition linking up the various areas nicely.

Some of the countries visited needed to be put in, so the names of the various places were printed off on the computer using some script-like fonts, printed onto thin photocopying paper that would stick down tightly and take paint or crayon. These were cut out and again glued down with care as they needed to be painted over in order to pull them into the composition. Some hand-drawn letters were also added. A map of the world and some flags plus very small photos were also printed off and incorporated into the composition. Some of the collage was torn around the edges and some was cut. Having this variety helps some things to blend in and others to stand out; the ragged edge of the paper takes the paint in a different way, which again adds interest and subtle changes in colour.

At this stage you should stop and stand back from your work and assess how it is progressing. How does the whole composition sit together? Is it comfortable to look at and are there things to be found that are not immediately obvious? Are the colours working? Does it need more detail or areas softened?

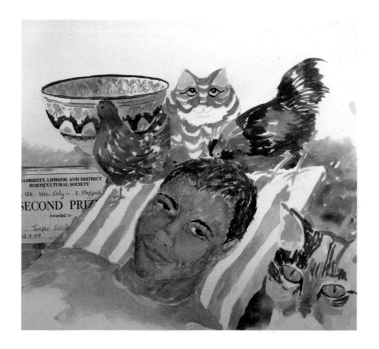

**More interest with the added objects and the portrait softened with extra colour.**

When you have answered all of these questions work on until you feel it is nearly finished. One of the great joys of working in this way is that it is very easy to block out areas that you are not happy with by adding more collage or painting out with acrylics or oil pastels. This leaves you with much more freedom but also many more decisions to make.

The composition needs pulling together with some more detailed drawing so crayons and black pens in various widths have been incorporated to bring the composition to completion. More paint has been stippled on to soften some edges and merge colours together. The various objects in the painting are not all immediately visible, which makes it a more interesting composition to look at and one that you can go back to and make more discoveries.

This has been an interesting piece of work to undertake and it was struggled with at a number of points. The portrait was difficult to get just right but of course you could use a photograph rather than your own painting here. In many ways it is far more difficult to work like this as you have to make your own design decisions throughout rather than just interpreting something that is set up in front of you. It is challenging, but very rewarding if it works, as you will end up with a very personal and original painting.

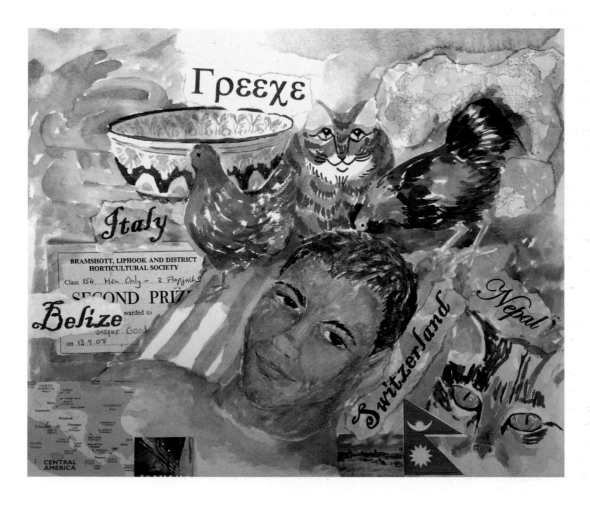

**The painting is finished with background used to soften some things and bring forward others.**

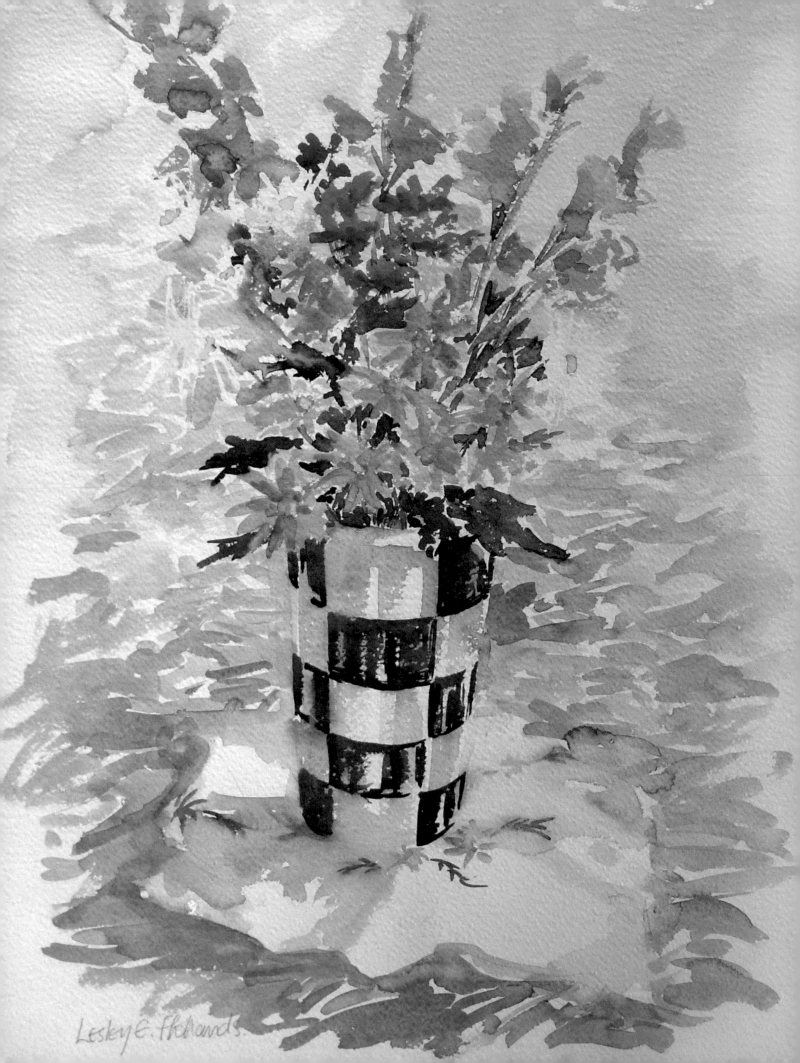

Lesley E. ffrollands.

# PROMOTING YOUR WORK

When you have reached the happy stage of having a body of work that you are pleased with, it is probably time to think about what you are going to do with some or all of your paintings.

There are various ways of showing off your abilities and selling your work. Joining a local Art Society is a good way of starting. They usually have annual exhibitions that are open to all members which, if well advertised, attract a good range of purchasing visitors, and the cost to you is usually pretty minimal.

Framing shops often like to display work especially if they have framed it themselves. Build up a good relationship with your framer and suggest they start putting on small shows if they don't already do so.

The local library will sometimes have exhibition space, which you can book, again usually for little or no cost. Hospitals and nursing homes like to have artwork on display as it makes their walls look more cheerful and attractive. They also like to sell work as they can then take a commission and help their funding; so you could consider that you are doing them a favour by allowing them to show your work.

Restaurants and pubs are another useful outlet to explore and with a constantly-changing stream of customers who are sitting looking at your work, there is a reasonable chance of selling something. Small businesses, cafes or your local garden centre are all possibilities, especially if your work fits the location: flowers for the garden centre, fruit and vegetables for a cafe and so forth.

OPPOSITE PAGE:
**Flowers against a flowery cloth.**

If you have enough work, then your own home can be a good venue for displaying your paintings. The overheads are lower and you can spend some time hanging the pictures and making them look attractive. Light your work well; borrow spotlights if your lighting is not bright enough. Second-hand spotlights can be found in car boot sales and flea markets, although it is probably worth getting a friend who is competent with electricity to check them out for you.

Don't be afraid to ask people to view. Number the work clearly and have a catalogue or price list that is easy to follow so people do not need to ask how much a painting is. Turn it into a bit of a party and offer wine and nibbles to encourage people to come. Often people who would be nervous about going into a gallery are very pleased to be asked to a viewing in a private home. They may have been longing to buy a piece of your work and been too shy to ask for a price. Invite friends, relations and neighbours and ask them to bring a friend so that you know, even if only slightly, the people who are coming. Start with a one or two day opening at the most, as it can be quite a strain doing this sort of thing to begin with.

One or two words of caution here though: do not put out general adverts saying that your house is to be open to the public – you just don't know who will come along. Put away any ornaments or objects that you would be sorry to lose either through theft or breakage. Have someone else with you, if only to be pouring out wine while you talk to guests and deal with sales. Check your house insurance for public liability. If you only have an occasional show and it's by invitation only, then you probably do not need public liability insurance, but it is best to check.

If you do not have enough work on your own or your house is not suitable for displaying large numbers of paintings, then

consider getting together with a group of fellow artists and hiring a local hall between you. You need to look at lighting, access, parking and how the paintings can be displayed. By having the exhibition in a public space you can then advertise it widely in local papers, on the radio and with posters put up in the vicinity.

Another possibility is to hire a private gallery. This can be very expensive so, again, try and find someone to share the space and cost with you. The advantage of a purpose-built gallery space is that it will be well lit and will already have installed a method for hanging the work. The gallery will also have some form of advertising set up and a list of people who like to come and buy paintings. Some galleries will expect you to man the exhibition yourself, so it is very useful to have one or more other artists or friends to share the duties. Make sure you or the gallery have adequate insurance.

When you have had some work on display and are feeling confident, it is time to branch out and try for a more professional venue. There are many small and not so small galleries that, of course, want to sell artwork.

Here are some guidelines to follow when approaching a gallery. Do not go in cold – ring, write or email first. Send them some photos of your work and ask for an appointment to bring some paintings over to show them. Gallery owners are extremely busy people and it is very demoralizing to be told to go away without even being able to show your work, especially if you have had to pluck up your courage to go in the first place. Present your work well; if it is badly framed it will look amateurish and will not give a good impression. Be confident about your work and do not apologize for it. It is a good general rule never to point out to anyone something that you feel is a mistake or that, to your eye, has not worked well. If you do not point it out there is a very good chance that others will not notice it at all. Have some idea of how much you would like to get for your work but be prepared to be flexible. Galleries will take a commission of anything up to around 70 per cent, which seems an enormous amount when you have done the work and paid for the framing and costs., but you have to remember that their overheads are pretty huge as well. Once you are very successful you may be able to negotiate a lower commission.

Another way of getting your work out on display is to put your paintings in for open exhibitions or competitions. There are all sorts of these, and dates, venues and requirements can be found on the internet or through artists' magazines that advertise them. There is usually a fairly hefty entry fee and, of course, you have to take your work to the collection point and then collect it if it is rejected, but it is well worth trying for. It is useful to look at the type of work that they accept, either by visiting an exhibition prior to entering or looking at successful past entries on the internet.

Pricing your work can be difficult, especially when you are starting out. One way of doing it is to take into account first the actual cost of producing the work: paint, paper, framing and other expenses, and have that as a base line. From there you go up, asking yourself, would I rather have this amount or keep the painting? Keep going until you feel that you would be happy to let the painting go and then add a little bit more for good measure. You then win on both counts: you still enjoy having the painting if it doesn't sell and you are pleased with what you get if you do sell it.

Another way of selling your work is through a website. There are programmes that you can buy to help you put together your own website but you need a good level of computer literacy in order to do this well. Shop around before you decide on someone to do it for you. Look at examples of their work and see how attractive it is and how easy they have made it to navigate around the site. Look at other websites generally and assess the ones that have a style that you like. How are the images presented? How do customers pay for work? Does it include postage and packing? Are paintings sold and sent framed or unframed? Is the work insured in transit? Do they sell abroad? How does it come up when you put in a search? And most important, is it easy to use and does it make you want to buy?

Once you have set up a website you need to keep it up to date, changing the images often enough for people to feel that you are an active artist. Put on a Curriculum Vitae and keep that up to date with anything new that you have achieved. Think of ways to make your site come to the top of any list that a search engine throws up. The best way is to put in lots of keywords, which will pick up anything that people might search by. Make it secure; you do not want people downloading images of your work and printing them off for nothing. Consider having prints made of some of your work and postcards or greeting cards so that there is a wider range of items and prices to encourage people to buy.

It is a great boost to have a painting in an exhibition and an even better one to sell a piece of work. Persevere, with determination; talent and hard work you will get there. Last of all do not be downhearted if at first you don't succeed. If you give up then you will never achieve fame and fortune, even on a very modest scale.

# ACKNOWLEDGEMENTS

I would like to thank Dr Jeremy Shaw for all his help and advice on spelling, grammar and punctuation and the time he spent putting them right. I would also like to thank my daughter, Saskia Gooding for her invaluable expert help and advice on the photographs for the book. Thanks also to Julian James for doing his very best to find the chapter I had over-written by mistake!

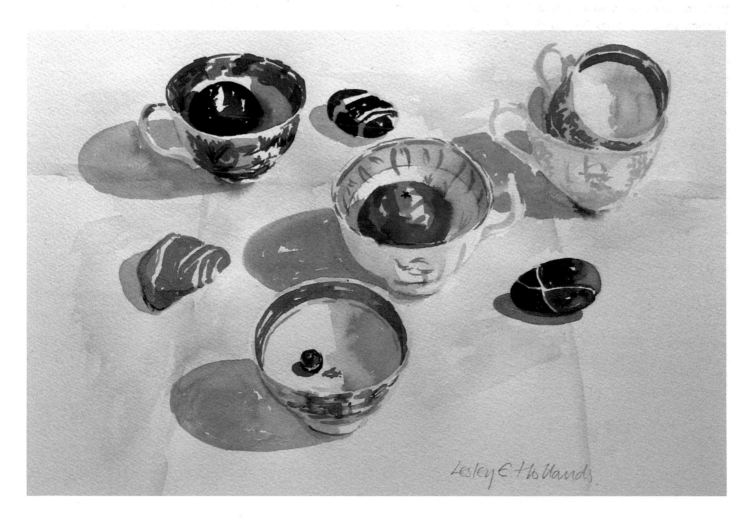

Lesley E Hollands

# FURTHER INFORMATION

## FURTHER READING

Andreae, Christopher *Mary Fedden: Enigmas and Variations* (Lund Humphries, 2007) An interesting book, showing the very individual approach to still life painting by British artist Mary Fedden.

Kay, Pamela *Gouache: A Personal View* (David and Charles, 1995) This book contains some inspiring paintings, which could trigger lots of good ideas for your own work.

Kellaway, Deborah *Favourite Flowers: Watercolours by Elizabeth Blackadder* (Pavilion, 1994) A colourful and inexpensive book about the flower paintings of Scottish artist Elizabeth Blackadder, written from the perspective of a gardening author.

The following books all contain a good range of illustrations and are full of interesting information about the history of still life painting. These are books to perhaps borrow from your local library.

Armstrong, Carol *Cezanne in the Studio: Still Life in Watercolours* (Oxford University Press, 2004) Campbell, Colin, and James, Merlin *The Art of William Nicholson* (Royal Academy of Arts, London, 2004)

Doty, Mark *Still Life with Oysters and Lemon: On Objects and Intimacy* (Beacon Press, 2002)

Hochstrasser, Julie Berger *Still Life and Trade in the Dutch Golden Age* (Yale University Press, 2007)

Mauner, George *Manet: The Still Life Paintings* (Harry N. Abrams, 2001)

McGregor, Neil, Jordan, William B. and Cherry, Peter *Spanish Still Life from Velazquez to Goya* (National Gallery Company Ltd, 1995)

Rathbone, Eliza E. *At Home with the Impressionists: Still Lifes from Cezanne to Van Gogh* (Universe Publishing, 2001)

Sander, Jochen *The Magic of Things* (Hatje Cantz, 2008)

Simms, Matthew *Cezanne's Watercolors: Between Drawing and Painting* (Yale University Press, 2008)

## USEFUL WEBSITES

www.royalwatercoloursociety.co.uk – the Society's own website.

www.hockneypictures.com – artist David Hockney's own website.

www.mikebernard.co.uk – website of a contemporary water-colourist.

www.myartspace.com – an online gallery where you can display your work and see the work of other artists.

www.artdaily.com – an online arts newspaper with interesting articles and information.

www.colourlovers.com – a fun site where you can find all sorts of interesting patterns to inspire you.

www.lesleyhollands.co.uk – the author's website, where you can view her work.

## SUPPLIERS OF ART MATERIALS ONLINE

www.winsornewton.com is accessible in USA and Britain and they offer advice as well as a range of their products.

www.daler-rowney.com is also accessible in the USA and Britain and if you register with their site, you can gain access to help, advice and various competitions. Again, they only sell their own products.

www.dickblick.com is an American site stocking a wide range of materials at competitive prices.

www.greatart.co.uk is a British-based company with very competitive pricing and fast delivery. There are many, many more so it is well worth comparing sites and prices.

# INDEX